POSTCARD SERIES

Cadillac

VINTAGE POSTCARD MEMORIES

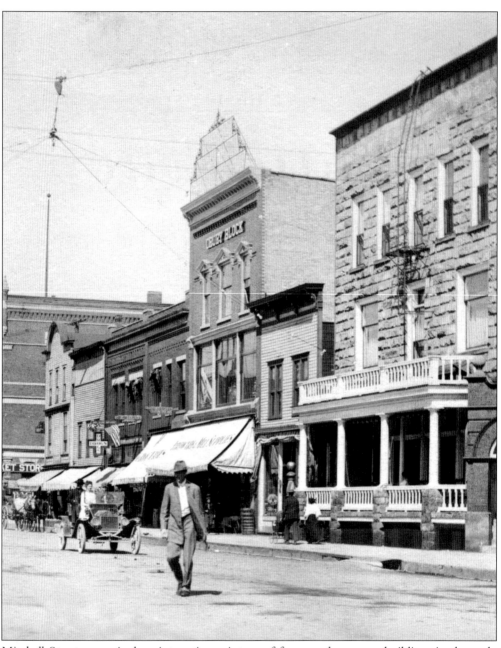

Mitchell Street comprised an interesting mixture of frame and masonry buildings in the early 1900s. A man crosses the street in front of the McKinnon House hotel at the corner of Harris. Hotel guests could relax on the large porch and watch the traffic pass through downtown Cadillac.

Front Cover Photograph: Crowds and automobiles begin to assemble in anticipation of an event on North Mitchell Street. This view of the business block between Harris and Mason Streets shows the Kelly Block building at far left. This building was purchased and remodeled by H. Chris Jorgensen in 1931.

POSTCARD HISTORY SERIES

Cadillac

VINTAGE POSTCARD MEMORIES

Debra Bricault

Copyright © 2002 by Debra Bricault.
ISBN 0-7385-2003-9

Published by Arcadia Publishing,
an imprint of Tempus Publishing, Inc.
3047 N. Lincoln Ave., Suite 410
Chicago, IL 60657

Printed in Great Britain.

Library of Congress Catalog Card Number: 2002107835.

For all general information contact Arcadia Publishing at:
Telephone 843-853-2070
Fax 843-853-0044
E-Mail sales@arcadiapublishing.com

For customer service and orders:
Toll-Free 1-888-313-2665

Visit us on the internet at http://www.arcadiapublishing.com

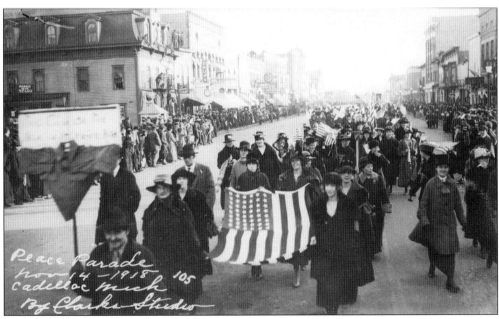

Women marching in the Peace Parade on November 14, 1918, three days after World War I ended, proudly display Old Glory.

CONTENTS

Acknowledgments		6
Introduction		7
1.	The Lakes and Canal	9
2.	A Stroll Down Mitchell Street	27
3.	Beyond Mitchell Street	57
4.	Lumbering and Early Industry	71
5.	The Great Ice Storm of 1922	87
6.	Personalities and Parades	93
7.	Streets and Residences	101
8.	Early Churches	113
9.	Schools of the Past	119
Index		127

ACKNOWLEDGMENTS

I wish to express my deepest appreciation and gratitude to those who have generously contributed postcards, photographs, personal memories, and historical reference for use in this book.

Postcards featured in this book come from the collections of the following: Debra Bricault, Ray Bricault, Bill White, Bob Holly, Keith Johnson, Lee Jorgensen Brown, Bruce Welliver, Steve Schut, Linda Durant, Kathy Wheeler, Wayne Ferris, Mark Snider, Barry Radawiec, Pat Goggin, the Wexford County Historical Society Museum, the Lake County (IL) Discovery Museum, and the Curt Teich Postcard Archives, L.L. Cook Co., Milwaukee, WI.

The following people have provided research and assistance: Ray Bricault, Carol Potter and the Cadillac Area Visitors Bureau, Jack Dillon, Keith Johnson, Kathy Wheeler, Ron Andrews, Lee Jorgensen Brown, Bob Holly, Dorothy Sorenson, Kelly Faloon, and Susan Stephenson.

Other sources I consulted while writing this book are as follows: the 1900 Cadillac City Directory, W.A. Norton, Publisher, ©1900; North Central Michigan Yearbook, Howard-Packard Land Co., ©1907; and the Cadillac Evening News Centennial History Edition newspaper, ©1971, used with permission; Mercy Hospital Report, 1908-1911.

I would like to express special thanks to Carol Potter, Executive Director of the Cadillac Area Visitors Bureau, for her endless support, encouragement, and friendship.

INTRODUCTION

Vintage postcards are windows through which we can view the past and marvel at "what used to be." Postcard images, especially those depicting views of "small-town America," typically illustrate subjects that were newsworthy and sources of great pride to the community. The quantity and variety of postcards that were produced for a town the size of Cadillac is truly astonishing, yet not entirely surprising. Cadillac was revered as one of the most progressive cities north of Grand Rapids in the early 20th century. Having forged its reputation as a prosperous lumbering and industrial center in the early 1870s, the town continued to thrive into the 1900s. With a population totaling nearly 6,000 residents by 1900, Cadillac had begun to realize its wealth and elevate its status in the form of civic improvements and the construction of several new buildings throughout town.

This book celebrates the variety of wonderful vintage postcards that portray the city of Cadillac from the early 1900s through the late 1950s. During these years, Cadillac watched the mills fade from its shores, as the decline of the lumber industry had become, at last, a harsh reality. The town was forced to seek out new industrial opportunities while also turning its attention to its biggest assets: the lakes. By the late 1950s, Cadillac had successfully reinvented itself as new industries emerged, and the town developed into a popular year-round tourist destination.

Incidentally, postcards did not become popular in the United States until the early 1900s. In 1901, the U.S. Government allowed the use of the words "Post Card" to be printed on the back of privately produced cards. Until 1907, personal messages could not be written on the backs of postcards; only the recipient's address was permitted. Typically, a brief personal message could be written on the front of the postcard, usually in a small strip of space provided for this purpose. This period in postcard history is commonly referred to as the Undivided Back Era.

After 1907, the U.S. Government finally permitted the use of postcards with divided backs, a trend that had already started in Europe. Personal messages and the recipient's address were allowed to share the backside of the card, and the front was devoted entirely to the image or artwork appearing on the card. Until 1915, many of the color-lithographed postcards were printed in Europe, particularly in Germany. The onset of World War I brought an end to this era, commonly referred to as the Divided Back Era. This period is also referred to as the "Golden Age" of postcards; they were at their height of popularity.

Many postcards depicting Cadillac from the early 1900s were actually portraits of people and buildings taken by local photographers. Although lithographic cards of Cadillac were still printed after 1915, "real photo" postcards appeared to be the most popular medium used locally after World War I.

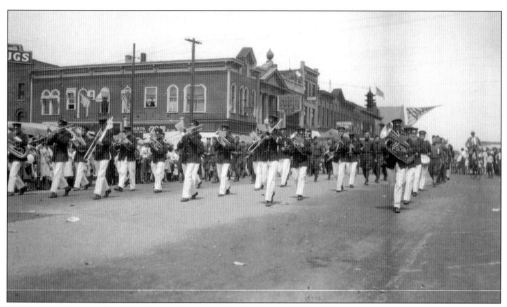
A parade progresses southward down Mitchell Street and passes over Harris Street *c.* 1930.

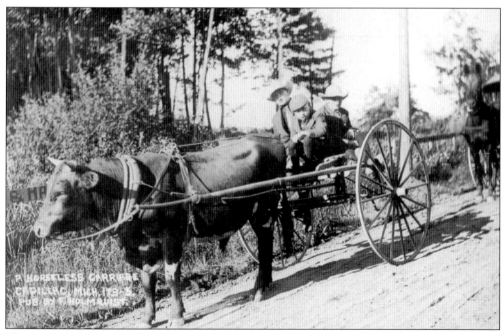
Three young boys take charge of the ox-drawn carriage that has stopped on one of Cadillac's many downhill streets. This snapshot, entitled "A Horseless Carriage," was meant to poke fun at the nickname given to early automobiles.

One
THE LAKES AND CANAL

This book begins by honoring Cadillac's most cherished natural resources, Lake Cadillac and Lake Mitchell (originally known as Little Clam Lake and Big Clam Lake, respectively). The lakes, of course, were here first. Before anything. They are the lifeline that delivered Cadillac from its earliest days as a booming industrial center to its largest present-day industry: tourism. Early Cadillac residents once relied upon the lakes for basic necessities such as drinking water and transportation. Excursion steamers provided the means to escape the cacophony of the downtown and venture across Lake Cadillac to more peaceful surroundings.

George A. Mitchell, who purchased the land at the east end of Little Clam Lake in 1871 to begin his new city, did not have recreation in mind when he first set eyes upon the two lakes amidst the thick pine forest. Instead, he envisioned a way to float freshly cut logs from Big Clam Lake to sawmills on Little Clam Lake. In 1877, the present canal was built on land owned by Mitchell, opening up the shortest distance between the two lakes and creating the most efficient way to transport logs.

The postcard images on the following pages focus on the beauty of the lakes and their place in Cadillac's history as sources of enjoyment and recreational activities.

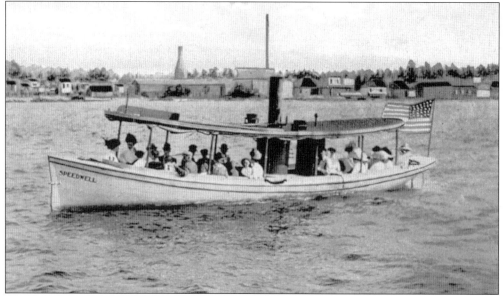

The Speedwell slices through the waters of Lake Cadillac. Steamers offered the fastest and most pleasurable means of transportation before reliable roads were constructed around the lake.

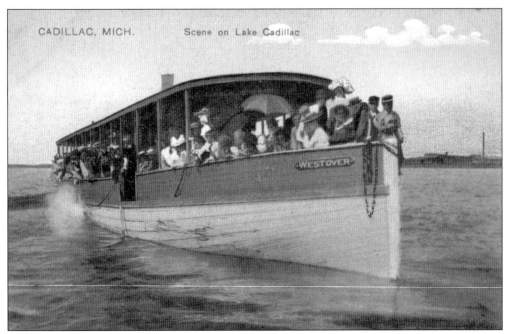

Passengers crowd the deck of the Westover, the largest of the excursion steamers, which provided transportation from the city dock at the east end of Lake Cadillac to destinations such as Kenwood, Idlewild (today, William W. Mitchell State Park), and Lake Mitchell.

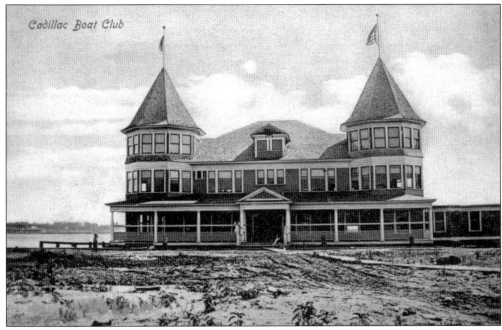

A recreational retreat amidst industrial surroundings, the Cadillac Boat Club opened in 1907 on the shores of Lake Cadillac at the foot of Pine Street. This imposing structure, with grand turrets and expansive verandas, served as a center for many social activities including dances and meetings.

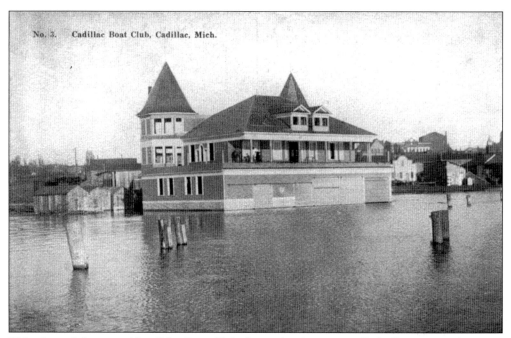

This view of the west side of the Boat Club shows that it was actually built out over the water on Lake Cadillac. Storage facilities for boats were located under the veranda. Unfortunately, fire destroyed the Boat Club in 1918 and it was never rebuilt.

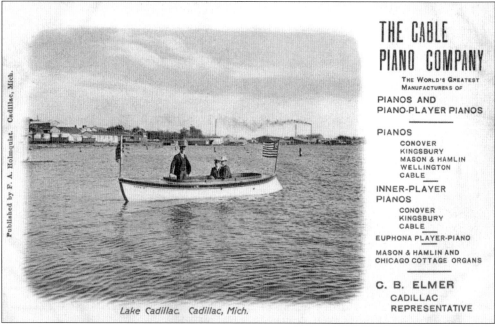

An early advertising card for The Cable Piano Company, this scenic view on Lake Cadillac provides a glimpse of recreational boating against the backdrop of lumber mills circling the southeast end of the lakeshore.

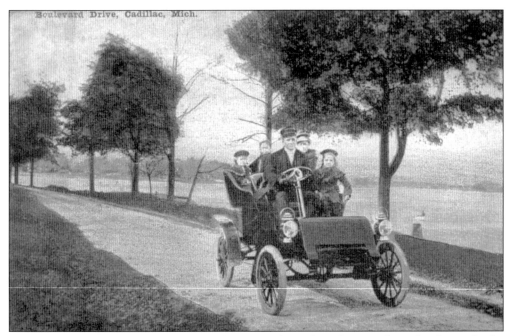

A family enjoys a leisurely automobile ride on North Boulevard Drive along the shore of Lake Cadillac in 1909. The drive around the lake remained a gravel road until 1916, when it was paved with concrete. To avoid accidents, patrons were encouraged to drive around the lake from north to south only, beginning at Haynes Street.

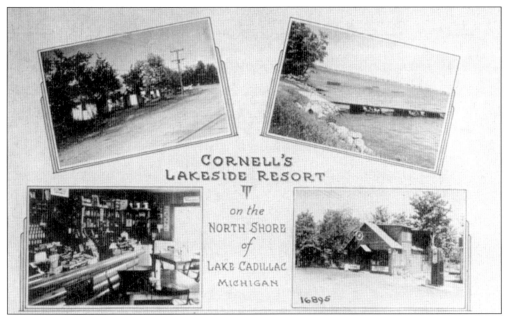

An advertising card, most likely from the 1930s, features inset views of the rustic Cornell's Lakeside Resort located on North Boulevard Drive. At Cornell's, tourists could rent small cabins overlooking Lake Cadillac. The main building featured a combination store, restaurant with dining tables, and what appears to be a bar.

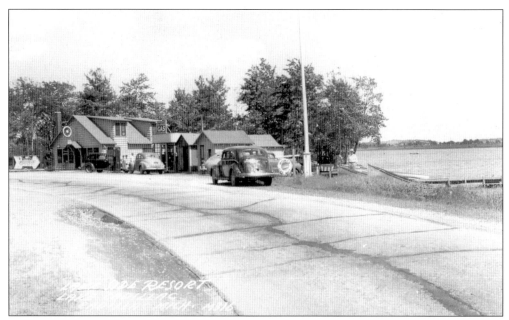

This familiar bend in the road on North Boulevard heads eastward past the Lakeside Resort (formerly Cornell's) in the 1940s. Although the establishment has changed names and owners over the years, it still operates as a tourist resort today—even though the location is much less remote than it used to be.

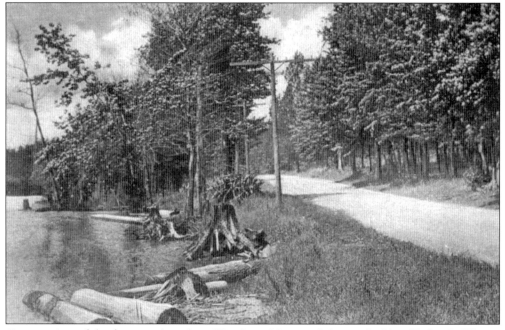

Construction of the first gravel road, or "Boulevard," around the north side of Lake Cadillac to the canal took place between 1890 and 1891. This view, looking west toward Kenwood in 1912, shows several weathered tree stumps discarded along the shoreline after they had been removed to clear the road. Stray logs, intended for the sawmills, often collected at the water's edge.

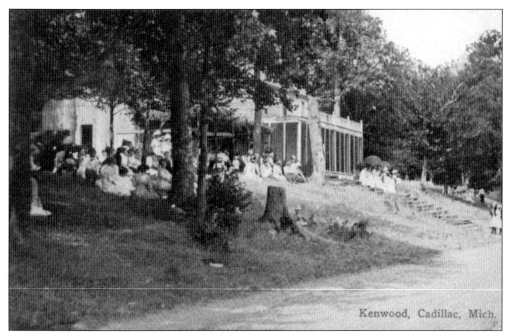

Pleasure-seekers could take a steamer from the city dock to the Kenwood resort area on the north shore of Lake Cadillac. Originally known as Taylor's Grove, the name was changed to Kenwood in 1906, after Sarah Schoonover purchased the site and built this inn on the terrace overlooking Boulevard Drive and the lake.

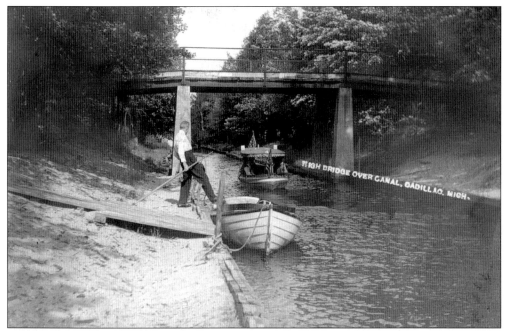

A steamer passes under the canal bridge as it ferries passengers between the lakes. The canal has been used for recreational purposes since the decline of the lumber industry, and serves as the north boundary of the William W. Mitchell State Park campground.

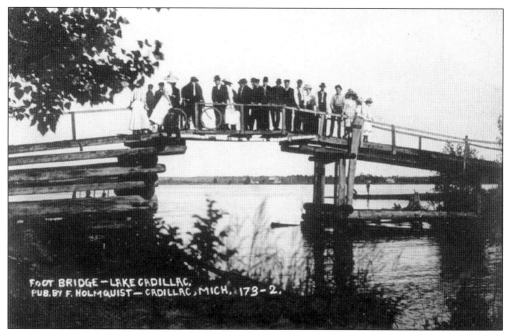

This wooden footbridge allowed passage from Boulevard Drive to Idlewild (now William W. Mitchell State Park) and was located where the canal opens into Lake Cadillac.

Members of the Cadillac Gun Club could shoot rounds or go fishing at this location on the north shore of Lake Cadillac. The Gun Club was located in the vicinity of the former Wesleyan Methodist campgrounds until 1927, when it moved east of Cadillac.

The Park of the Lakes Pavilion was built by the Holmen Brothers in 1917 as a recreational facility near the canal off North Boulevard. A popular place for weekend dates, patrons could enjoy food, dancing, roller skating, and boat rentals. This establishment later became The Platters. The roof collapsed in the mid- to late 1970s, and it was razed shortly thereafter.

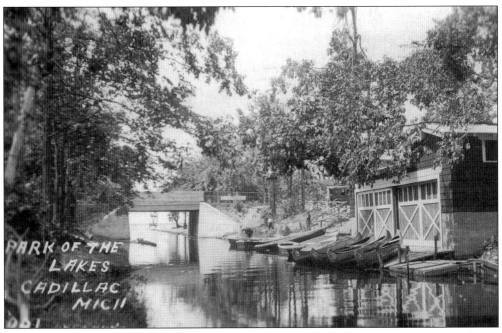

Canoes and rowboats could be rented at the Park of the Lakes livery, situated on the canal, and taken out onto either lake.

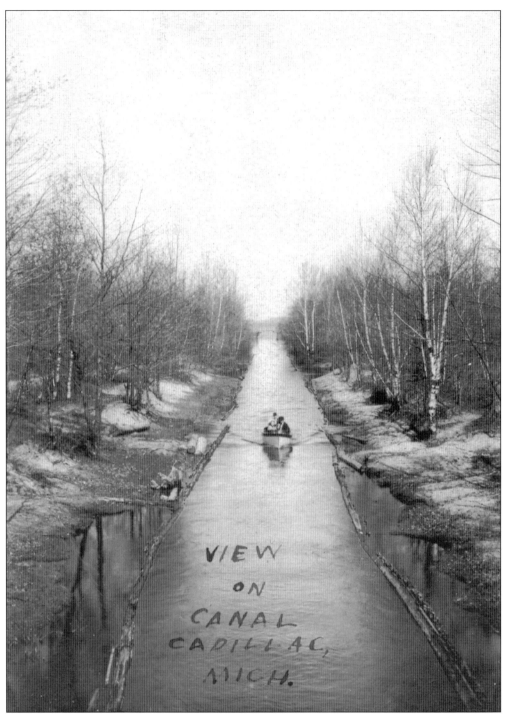

Originally constructed to float logs from Big Clam Lake (Lake Mitchell) to the mills on Little Clam Lake (Lake Cadillac), the canal cuts through the narrowest portion of land that separates the two bodies of water, and it spans one-third of a mile. This early view of the canal shows how narrow it used to be before it was expanded to its present width of 48 feet.

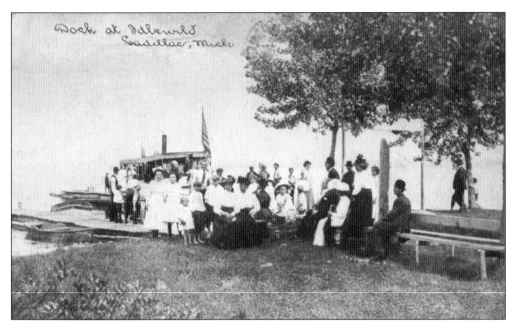

Away from the bustling downtown and industrial commotion at the east end of Lake Cadillac, Idlewild, now named William W. Mitchell State Park, was a popular haven for picnics and social activities. Steamers provided passenger service between the city dock and Idlewild for a small fee.

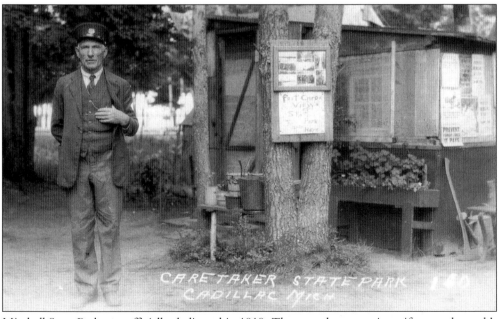

Mitchell State Park was officially dedicated in 1919. The caretaker poses in uniform at the park's entrance, near a tree bearing the sign: "Postcards. Views of State Park For Sale Here." The selection of postcards was prominently displayed above.

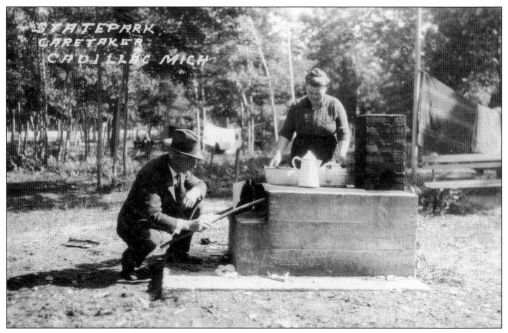

A woman appears to be boiling water for coffee, as the State Park caretaker tends the fire in the outdoor stove.

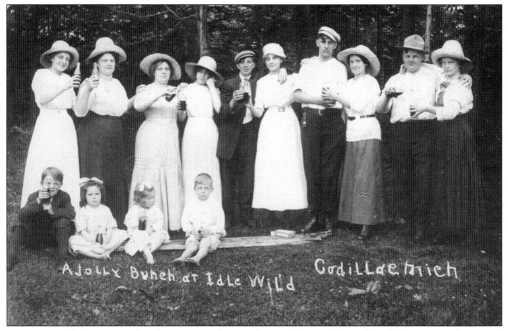

It was a swell place to gather for summer fun, and "A Jolly Bunch at Idlewild" captures the mood of this group as soda bottles are raised in a toast.

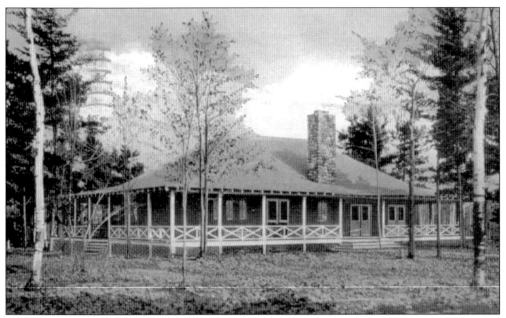

Constructed in Mitchell State Park in 1924, the Shelter House was a one-room pavilion with a wrap-around porch. The facility had a large fireplace at one end of the open room. It served a variety of purposes, and was particularly useful for family reunions or indoor dining when it rained. The building was razed in the 1950s.

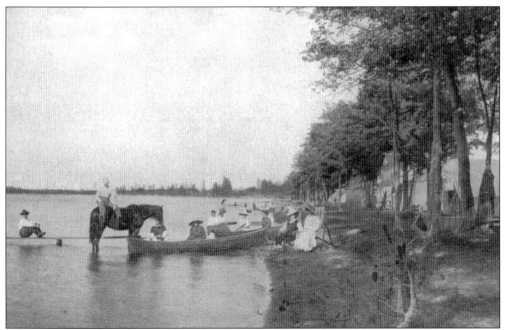

White City was the name given to the community of white tents that were pitched by campers every July and August along the shore of Lake Mitchell, just north of the canal. Cadillac residents could enjoy the summer's hottest months while camping in this relaxing setting.

A summer home overlooks beautiful Lake Mitchell in the late 1920s. Many year-round and seasonal residences were situated on the long drive around this lake.

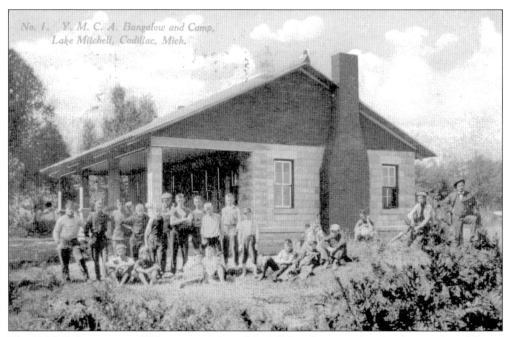

The Y.M.C.A. camp, or "Y" camp, originated in 1906 and operated at the former site of Camp Doxie, at the far west end of Lake Mitchell. In 1938, the camp was purchased by the Board of Education. It was officially named Camp Torenta in 1953, which is an Indian name meaning "land of the tall pines."

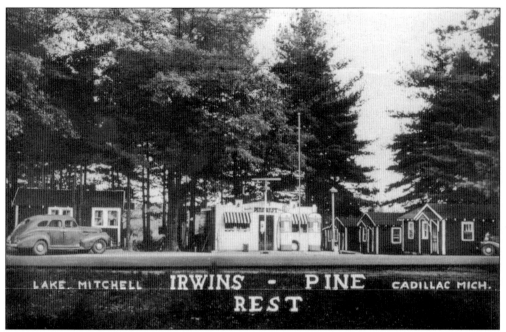

An increase in tourism in the Cadillac area, beginning in the early 1920s, prompted the arrival of modest resort cabins at both lakes. Typical of many early tourist courts, Irwin's Pine Rest, shown here in the 1930s, was located on the south shore of Lake Mitchell and featured a small store and gas station.

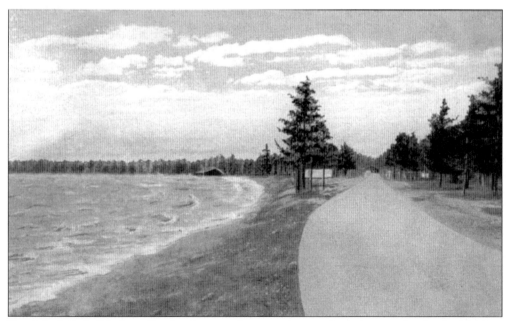

East Lake Mitchell Drive offered early motorists a scenic tour along the water's edge in this view from the 1920s.

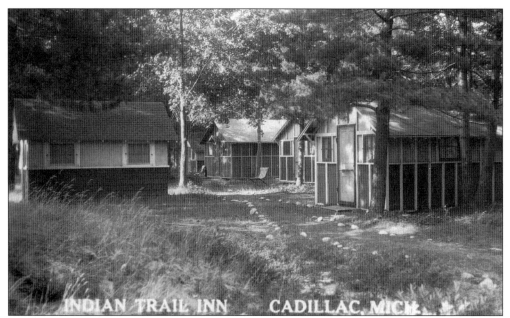

Intended to be one in a series of several resorts planned along old Native American trails in northern Michigan, the Indian Trail Inn opened between the lakes in the early 1920s, where the Sun 'N Snow Resort is now located. This site was renowned for the many Native American burial mounds that were discovered in this region.

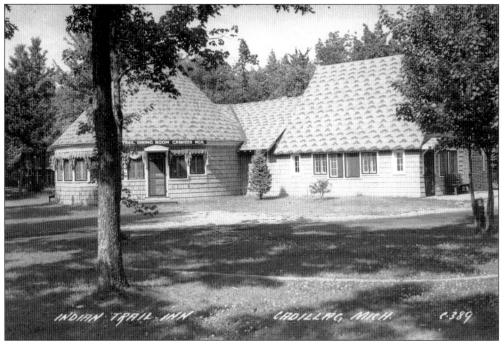

This charming shingled building with a cozy round dining room and main resort office (to the right), proved to be a worthwhile addition to the Indian Trail Inn. The restaurant became a popular spot for both tourists and Cadillac residents alike.

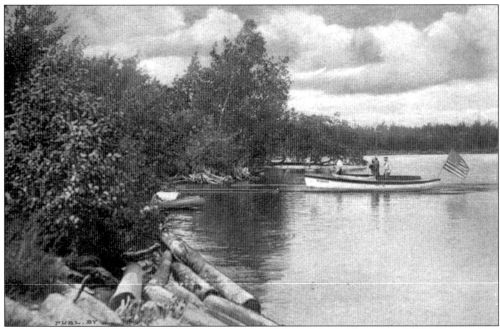

A small craft enters the canal from Lake Cadillac near Idlewild (now William W. Mitchell State Park). During the lumber era, lumber companies used to float logs through the canal to reach the sawmills at the east end of Lake Cadillac. Many would drift off course, however, and accumulate along the shoreline.

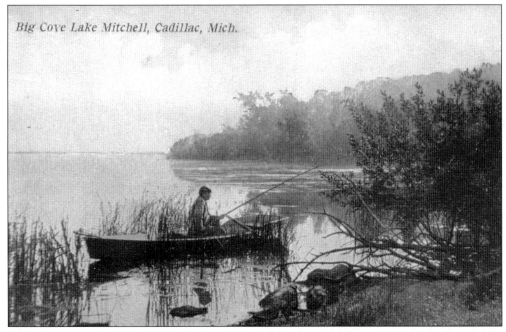

At the far west end of Lake Mitchell where Hemlock Park camp is located, Big Cove is a popular fishing spot. This 1910 image captures a fisherman, with line cast, in the calm waters of this secluded area.

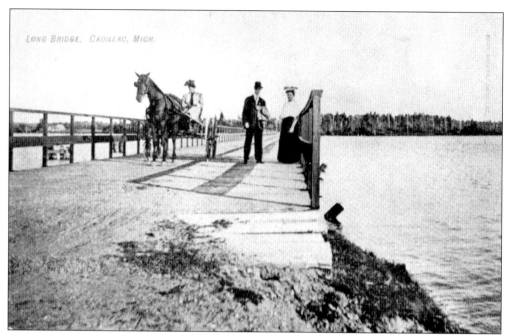

Early traffic is shown on Long Bridge, the narrow wooden bridge that once spanned Little Cove on Lake Cadillac. Originally built to accommodate logging trains, Long Bridge was modified and became part of the drive circling the lake after the first roads were constructed in 1890. This is now the causeway where M-115 and M-55 converge and cross over Little Cove.

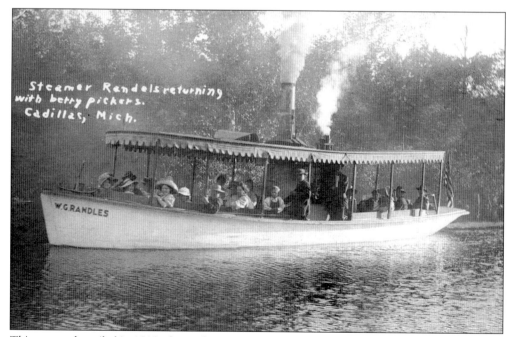

This postcard, mailed in 1912, shows the excursion steamer W.G. Randles as it returns from Lake Mitchell with berry pickers on board.

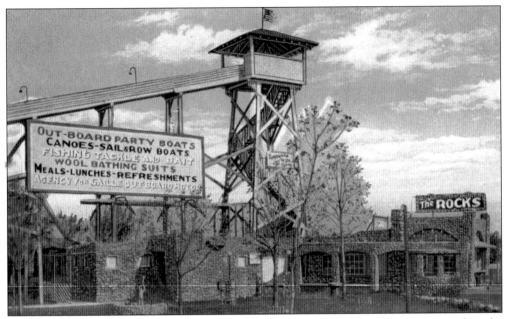

A peculiar and almost forgotten attraction, the Rocks resort and bathing beach once stood on the south shore of Lake Cadillac on Sunnyside Drive. As one might guess, the rock theme was carried throughout the resort, and large rocks were used on the exteriors of all buildings. The toboggan slide was not a success and was later removed.

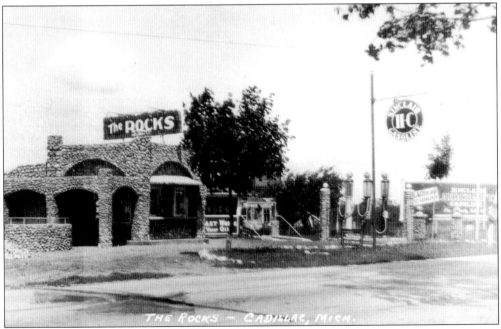

A rare close-up photo of the Rocks reveals that it also served as a Sinclair gas station. Note the tall gas pumps and Sinclair Gasoline sign on the right. The Rocks eventually closed and the South Shore Motel was built in its place. The Sunset Shores Resort now occupies this site.

Two
A Stroll Down Mitchell Street

Scenes from Mitchell Street, downtown Cadillac's broad and busy thoroughfare, have appeared in countless vintage postcards since the early 1900s. These images, when viewed collectively, serve as detailed records of how the business district has evolved over time. Before the arrival of strip malls and national retail chains at the north end of town, the independent merchant thrived in downtown Cadillac. The city was a bustling center of commerce, attracting shoppers from several nearby communities. The majority of businesses and historically significant buildings depicted in postcards of Cadillac were situated on Mitchell Street between North and Chapin Streets. The images in this chapter have been arranged to reenact a visual "stroll" down Mitchell Street, beginning at North Street and continuing south to Chapin Street.

Mitchell Street was named after George A. Mitchell, founder of the village of Clam Lake (later Cadillac). Old city directories reveal that, prior to 1934, the boundaries of Mitchell Street differed from what they are presently. North Mitchell was defined as beginning at Harris Street, extending northward to River Street and then becoming Haring Street. Conversely, South Mitchell was defined as beginning at Harris Street, extending southward to Howard Street, and then becoming Wood Street. After 1934, the use of Haring and Wood as street names was discontinued, and Mitchell Street extended to the city limits in both directions.

A post-World War II linen card shows South Mitchell Street looking north from Cass. During the 1940s, many changes took place on the block between Cass and Harris: Kelly's Restaurant moved into the former Cadillac State Bank building, F.W. Woolworth Co. expanded and remodeled, and the H.L. Green & Co. dime store opened after remodeling the Granite Block building.

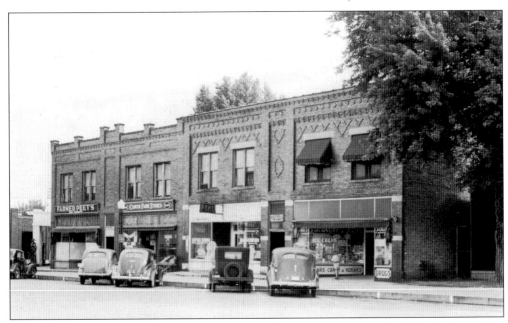

These two buildings comprised the small business block located just south of North Street. The building shown at left is the Ernst Building, built by butcher Fred Ernst in 1906. This view from the 1930s shows the following storefronts (left to right): Farmer Peet's Meat Products, Clover Farm Stores, Little Tavern Restaurant, and People's Drugs.

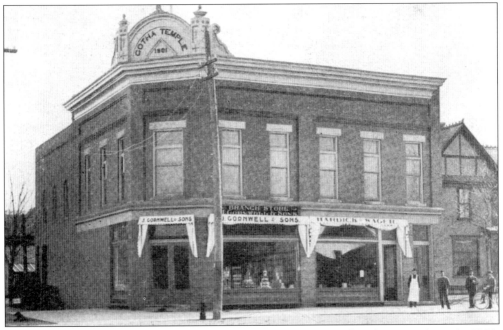

The Gotha Aid Society built the Gotha Temple on North Mitchell and Bremer Street in 1901. The second level housed a large meeting hall, and two storefronts occupied the first level. This building still stands and has served as the American Legion Post No. 94 since 1946. The ornamentation on the top of the building has been removed.

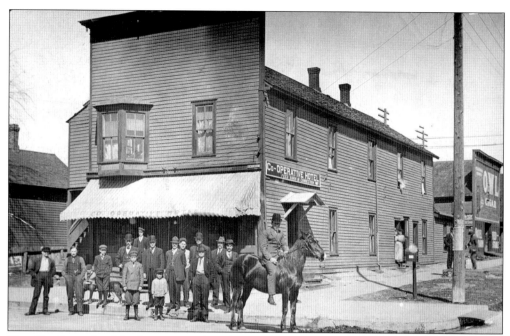

The Co-Operative Hotel once stood at the northeast corner of North Mitchell and Nelson Streets. Little is known about this weathered-looking establishment except that it was owned by Dr. Leeson, Cadillac's first physician. The feed barn, which served as the hotel's stable, was located behind the building.

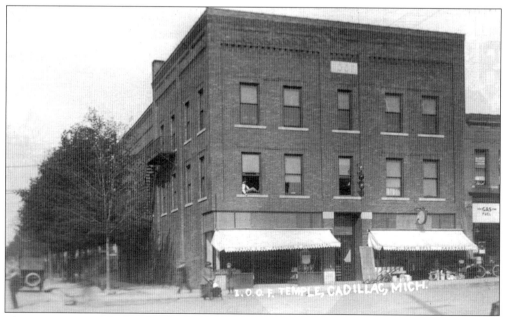

The new I.O.O.F. (Odd Fellows) Temple, constructed on the former site of the Jacob Cummer residence on North Mitchell and Pine Streets, was built in 1914 to replace the former Odd Fellows Block on South Mitchell. Still in use today, this three-level building contained two storefronts and a ballroom on the third floor.

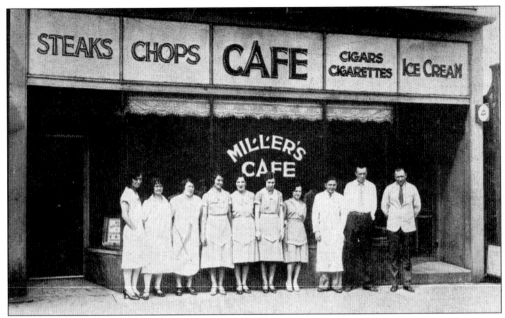

"Where service & food quality is our slogan. You must be satisfied if you eat at Miller's. CAFE ALWAYS OPEN," reads this advertising card from 1936. Miller's Cafe is shown at its original location at 213 North Mitchell on the west side of the street. The cafe later moved across the street, where it remained in business for many years.

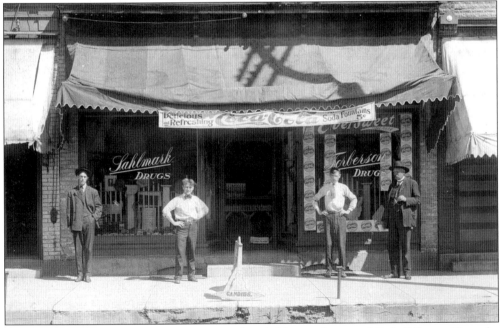

Sahlmark Drugs and Torberson Drugs once shared this storefront on Mitchell Street. Note the Coca-Cola banner advertising their soda fountain. It is believed that "Torberson" Drugs later became "Torbeson" Drugs (the "r" was dropped) and moved to the northeast corner of Mitchell and Spruce Streets.

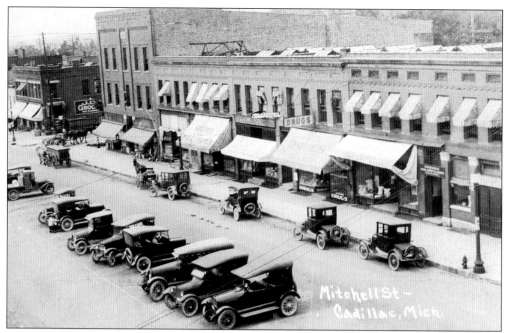

Automobiles were allowed to park at an angle in the center of Mitchell Street until it was banned in 1926 for safety reasons. Although automobile ownership had noticeably increased during the early 1920s, horse-drawn wagons were still making delivery rounds on Mitchell. This elevated view of the commercial block between Spruce and Pine Streets shows traffic on a typical business day.

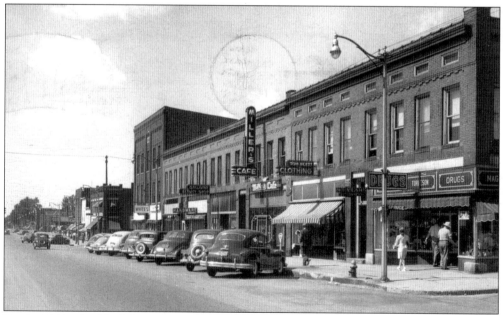

By the 1940s, this block had changed in appearance as storefronts were modernized to reflect the latest trends, and neon signs appeared over some businesses. Torbeson Drugs, Tom Plett Clothing, Miller's Cafe, Gallivan's Beauty & Barber Shop, Drury Hardware, and White's Hardware could be found between Spruce and Pine Streets in this view from 1948.

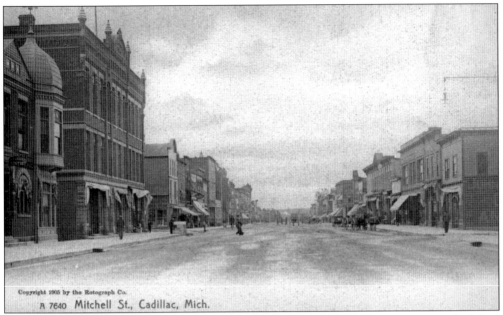

The original Cummer Lumber Company office building, built in 1890, is depicted at far left in this panorama of Mitchell Street looking south in 1905. The three-story Masonic Temple, next to the Cummer offices, was built in 1889 and leased space to the offices of Wexford County until the courthouse was opened in 1913.

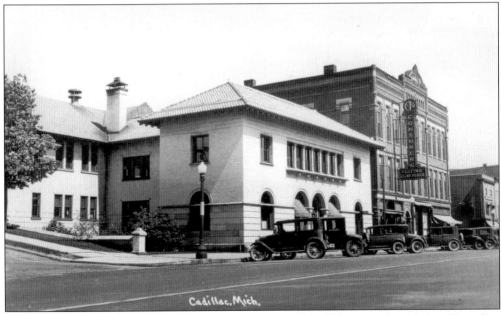

The Cummer & Diggins office building was constructed in 1909 to replace the smaller office building occupied by the Cummer Lumber Company. The decorative edifice complemented the block between Spruce and Beech Streets and enclosed an equally impressive interior. The building was acquired by the Cadillac Evening News in 1936 and remains in use by the newspaper today.

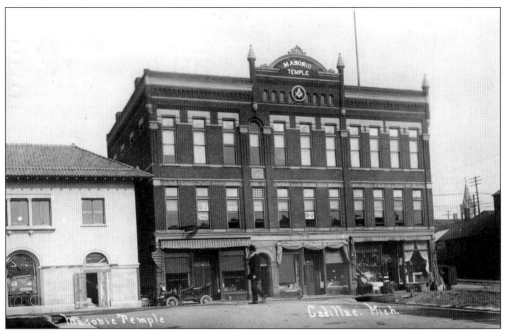

This detailed photograph of the Masonic Temple from 1909 documents the original ornamentation and small decorative windows that once topped building's facade. Construction of the new Cummer & Diggins office building is shown in progress at left.

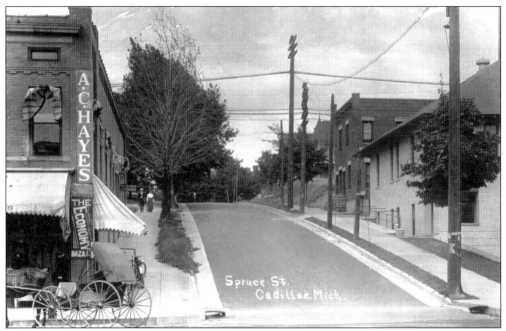

A horse and buggy rest in front of the Economy Bazaar on the corner, and a couple strolls down the sidewalk on Spruce Street *c.* 1909. A small brick building, nestled half way up the hill on Spruce, served as a bathhouse owned by Guy Copier.

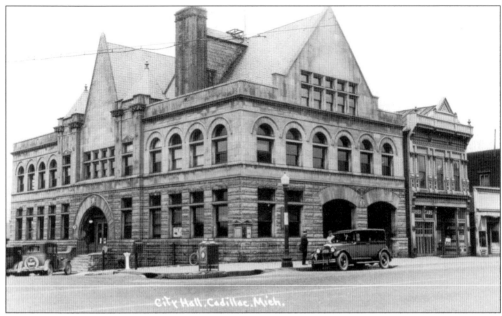

One of the most architecturally unique facades remaining on Mitchell Street is the old city hall. Constructed in 1901, the building housed city offices, police and fire departments under one roof. In this 1920s photograph, members of the fire department are conversing near the parked automobile.

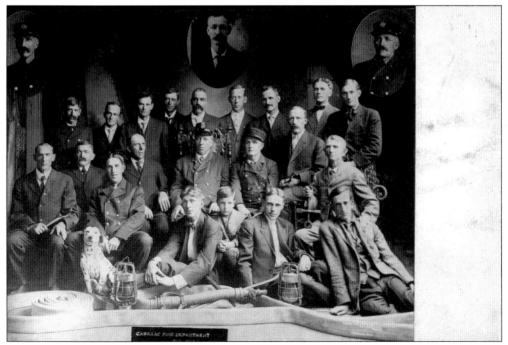

Members of the Cadillac Fire Department pose with their mascot and firefighting equipment in 1910. In the days when homes and businesses in Cadillac were heated with fireplaces, wood-burning stoves, and coal, these gentlemen were kept rather busy extinguishing frequent chimney fires.

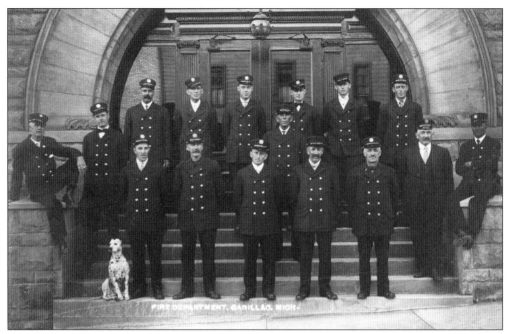

This portrait of the fire department in full uniform was taken on the south entrance steps of the old city hall. Cadillac firemen responded to alarms using horse-drawn equipment until 1917, when the fire department received its first motorized vehicle, a locally produced and fully outfitted Acme fire truck.

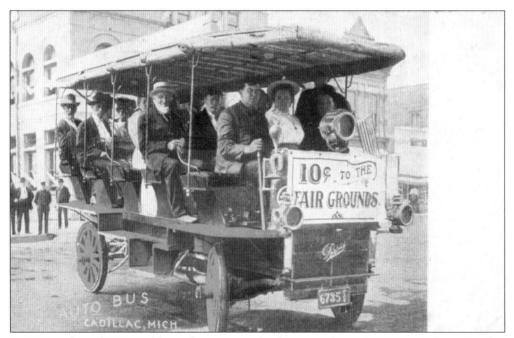

In 1908, a fare of 10¢ would pay for a trip to the fair grounds on the new auto bus. At other times, the auto bus would be used as a shuttle between railroad depots and hotels and make scheduled trips around Lake Cadillac.

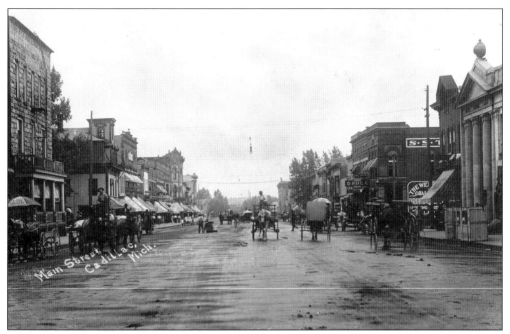

In 1908, carriages and wagons still outnumbered autos, as seen in this view that captures the four corners of the Mitchell and Harris Street intersection and shows the following businesses: McKinnon House, northeast corner; American House, southeast corner; Arthur Webber Drugs, southwest corner; and Present's Dry Goods, northwest corner.

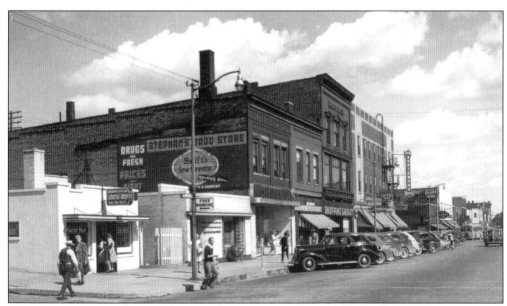

Shoppers enter the Snow White Sandwich Shop for an afternoon lunch break. Many well-known businesses occupied this block between Beech and Harris in this late 1940s view, including Stephan's Drugs, which opened in 1946 at 112 North Mitchell. Stephan's was followed by Knapp's Clothing, the Shopping Basket, Sandy's Jewelry, the Northwood Coffee Shop, and English News Agency.

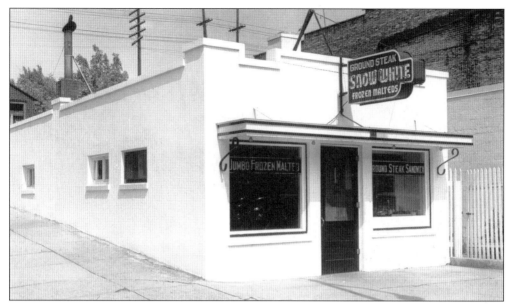

Best known for deep-fried curly hot dogs and delicious burgers, the Snow White Sandwich Shop served up wonderful memories for many Cadillac residents at this location on the corner of Mitchell and Beech Streets. The restaurant closed in the early 1970s and was remodeled for use as a radio station. Today, this building is used for retail space.

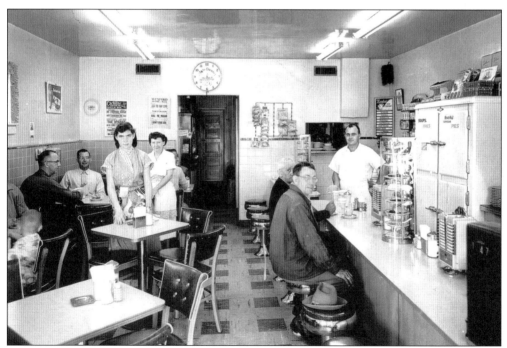

Ray Bricault, shown standing behind the counter, purchased the Snow White Sandwich Shop in 1947, and moved to Cadillac from Saginaw, Michigan. A local photographer, Jess Johnson, was commissioned to take this interior photograph after new restaurant fixtures and tile flooring were installed. Note the jukeboxes and pie cases on the counter top.

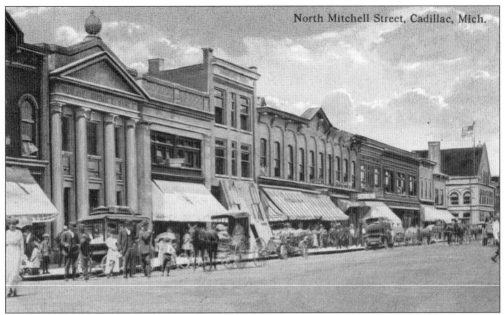

It is a busy day on Mitchell Street, as Popcorn John's wagon lures shoppers with the smell of fresh popcorn in front of the Peoples Bank. The tall building under construction in the center of this photograph is the Jorgensen Block. H. Chris Jorgensen, owner, completely remodeled the building in 1911, adding a third story. His clothing store occupied the first level until 1931.

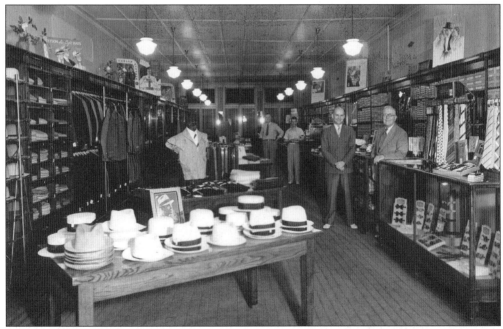

This photograph, showing the interior of H. Chris Jorgensen, Clothier, dates from 1938 and shows the meticulously arranged merchandise displayed throughout the store. Mr. Jorgensen started his clothing business in 1901 and relocated to this space in 1931. Pictured left to right are, as follows: Enoch Hedequist, Dick Watson, Ted J. Brown, and H. Chris Jorgensen.

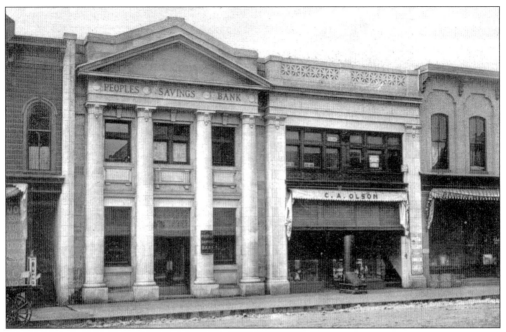

The Peoples Savings Bank moved to their own building on Mitchell Street in 1907, after operating from the Russell House hotel lobby for five years. The bank struggled financially in the late 1920s and closed in October 1931. C.A. Olson Shoes, located next door, was best remembered for the large boot that was rolled onto the sidewalk during business hours.

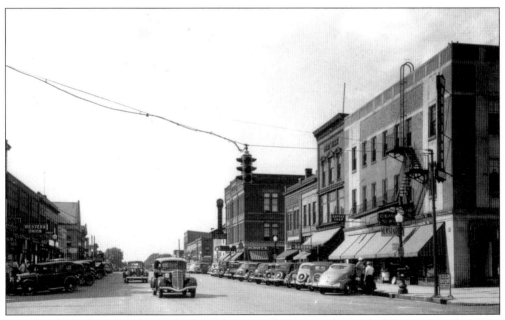

Not a parking place in sight on this busy shopping day on North Mitchell Street, c. early 1930s.

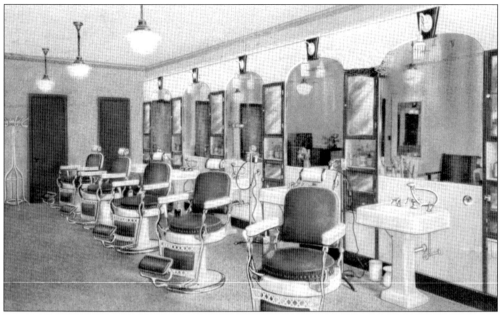

Guests staying at the Northwood Hotel would not have to wait long for a shave and haircut in the stylish 5-chair Northwood Barber Shop.

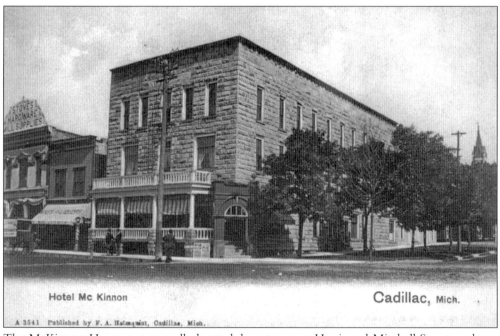

The McKinnon House was centrally located downtown on Harris and Mitchell Streets and was Cadillac's most revered hotel in its day. This detailed photograph, c. 1905, clearly shows the building's most distinguishing features: the sandstone facade, corner entrance, and shaded sitting porch. In 1928, the McKinnon House was expanded and remodeled into the Northwood Hotel.

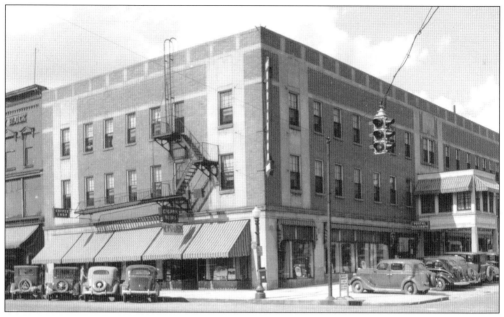

The Northwood Hotel was an extensive renovation of the McKinnon House, costing approximately $350,000 in 1928. The impressive facade was faced with red brick and stone, and a new portico was built over the Harris Street entrance. Storefronts were added at street level along both sides of the hotel.

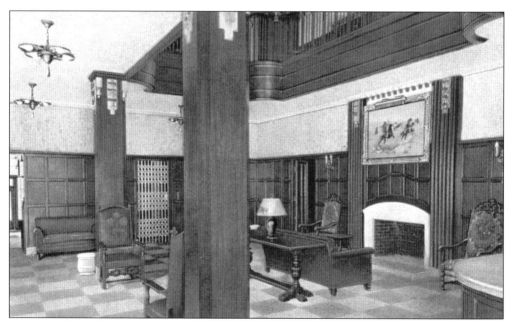

The well-appointed interior of the Northwood Hotel included this inviting fireplace in the lobby and gorgeous woodwork throughout the main level. The open area on the second level overlooks the lobby below.

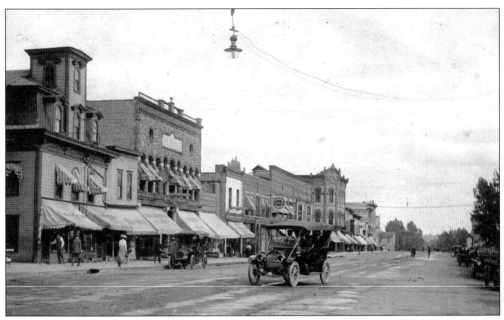

There were no traffic lights in sight when this photograph was taken at the intersection of Harris and Mitchell Streets. In 1905, the speed limit through town was regulated to eight miles per hour, and drivers were supposed to stop if horses became frightened.

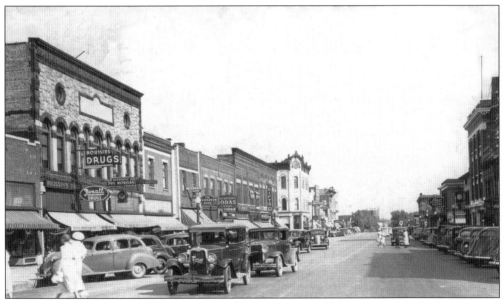

Downtown Cadillac was a shopping center for many surrounding communities in the area, and this same view of South Mitchell Street from 1940 shows the growing need for accommodating the rise in automobile traffic. Off-street parking was finally provided in the 1950s with the addition of a parking lot that replaced the Pennsylvania Railroad Depot.

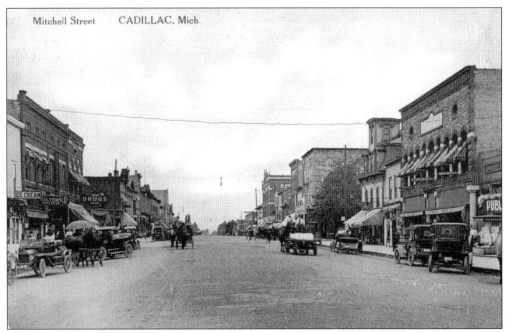

This panoramic view of Mitchell Street captures the essence of the downtown in the 1910s.

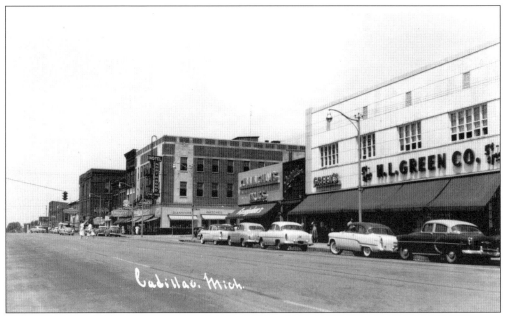

The H.L. Green Co. celebrated the grand opening of their new dime store in 1941. After acquiring the Granite Block building, Green's expanded its width to include a third storefront and covered the gorgeous stone facade with green tiles to "modernize" its appearance. Cunningham's Drug Store is also visible on the corner of Harris in this view from 1960.

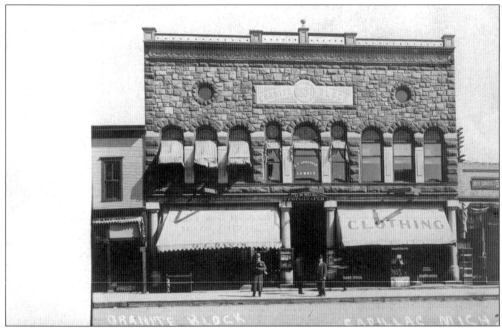

Dr. Wardell, a prominent surgeon, built the Granite Block in 1897 to provide office space for his practice and two storefronts. The 1900 Cadillac City Directory describes the decorative exterior of the building as "one of the richest to be found anywhere." Three types of stone were combined on the facade of the upper level to offer a variety in color and texture.

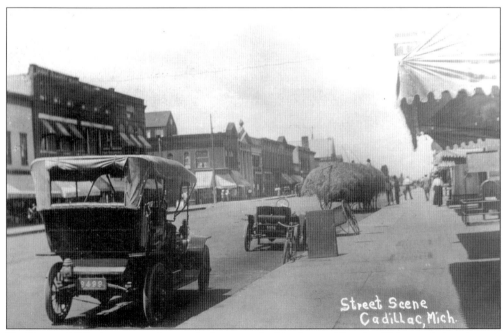

Dr. Devere Miller's new touring car is shown parked in front of Reed & Wheaton's Jewelers on South Mitchell Street.

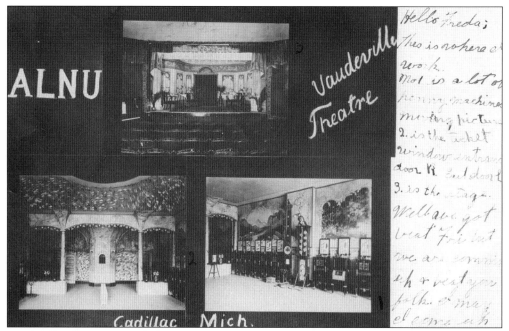

Vaudeville theaters provided entertainment along Mitchell Street in the early 1900s. Some establishments even featured early moving pictures. This advertising card, sent by a theater employee, features the ALNU (pronounced "All New") Vaudeville Theater located in the 100 block of South Mitchell Street. Inset photos depict the stage, admission window, and penny arcade machines in the lobby.

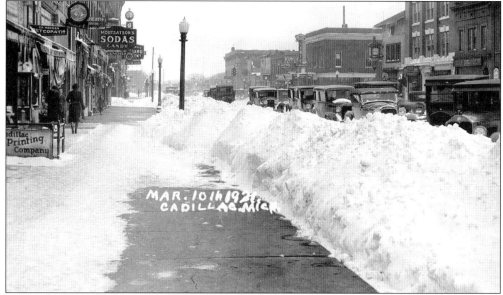

Sidewalks have been cleared in the 100 block of South Mitchell Street following a blizzard, which hit the area in early March 1931. Signs for the Cadillac Printing Company and Moutsatson's Sodas stand out on the east side of the block. At the intersection of Cass and Mitchell, the Cadillac State Bank and the Lyric Theater are visible.

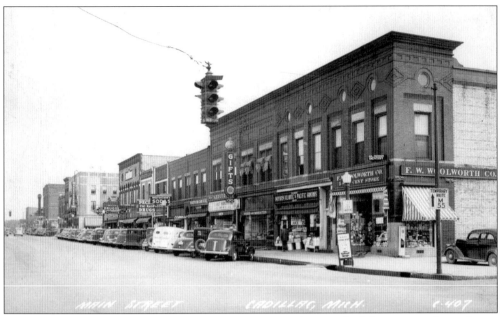

In 1939, the east side of Mitchell Street, between Cass and Harris, had four occupied storefronts. They are, as follows: F.W. Woolworth Co., A & P Foods, Reed & Wheaton Jewelers, and Kroger's. These two buildings were modified shortly after this photo was taken. The upper portion of the second floor was reduced in height over Reed & Wheaton and Kroger's, and Woolworth's expanded.

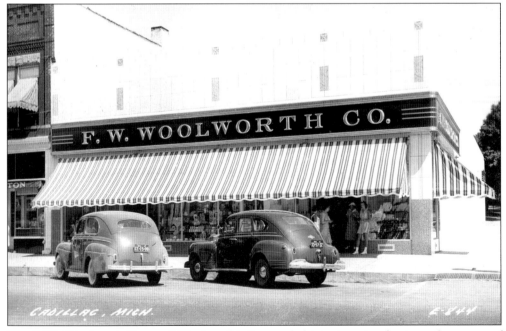

The F.W. Woolworth Co., or "Woolworth's," expanded into two storefronts on the corner of Cass Street c. 1940 and completely remodeled the building, removing the second level. The look of the new facade conformed to the modern style adopted by the F.W. Woolworth chain.

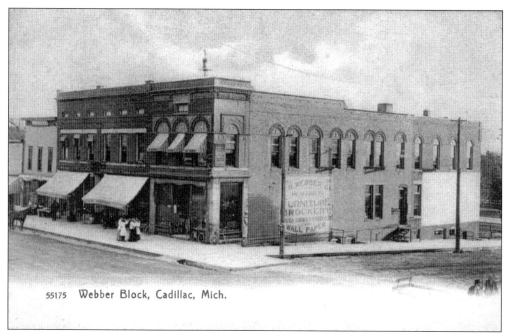

55175 Webber Block, Cadillac, Mich.

The Webber Block building, on the southwest corner of Mitchell and Harris Streets, was home of the A.H. Webber Co. store in the early 1900s. Webber offered a wide variety of goods in his store from books to furniture; it was also known as a drug store. The large expanse of wall facing Harris Street, below the arched windows, was often used for large hand-painted advertisements.

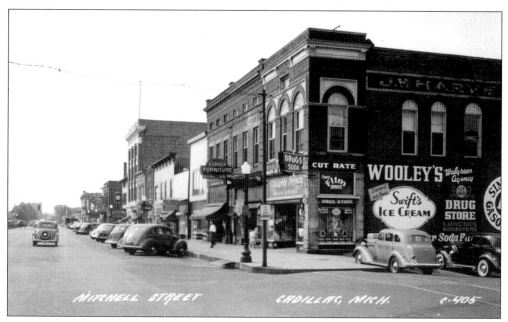

Wooley's Drug Store moved into the Webber building in the 1930s and became well-known for the delicious ice cream treats served at the soda fountain. This photograph shows a nicely detailed photo of Wooley's storefront and other businesses on this block in the early 1940s. The J.C. Penney Company leased the building in 1950 and it was extensively remodeled.

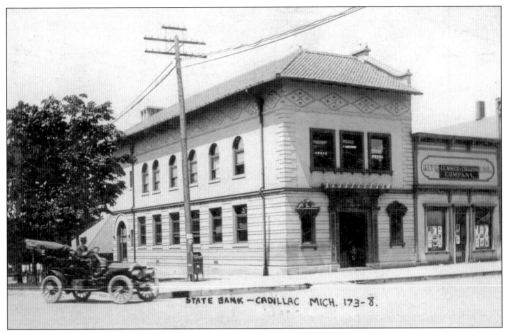

The Cadillac State Bank built this handsome yellow-brick building on the corner of Mitchell and Cass Streets in 1901. This photograph, c. 1911, shows the building with the original hipped roof, now gone. After the Cadillac State Bank purchased the former Peoples Savings Bank in 1941, this building was sold to George Kelly and became Kelly's Restaurant for many years.

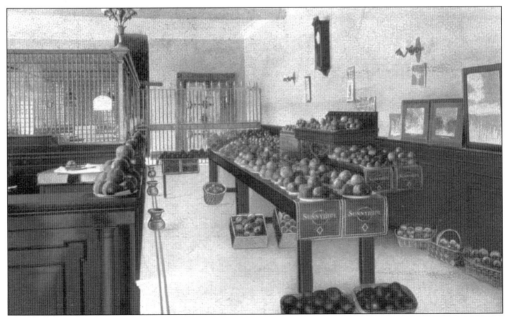

The interior of the Cadillac State Bank shows fresh fruit from Wexford County on display.

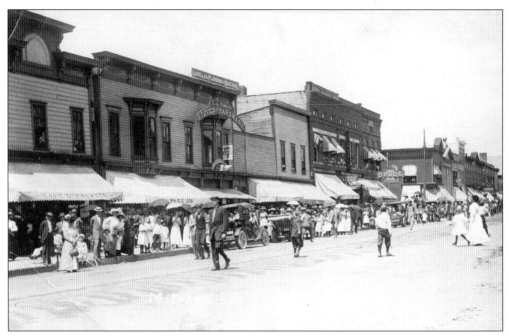

Residents gathered for a special event on Mitchell Street and appear to be wearing their finest clothes for the occasion. This view, from the early 1910s, shows the west side of the block between Cass and Harris Streets with many of the old frame buildings still in use at the time.

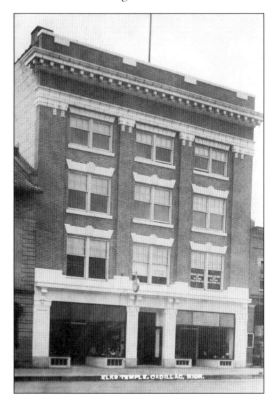

The Elks' Temple, downtown Cadillac's tallest building with four stories in all, was built in 1911 at a cost of approximately $53,000 and was dedicated in April 1912. The first floor of the building had two storefronts, and the large meeting hall was on the third floor.

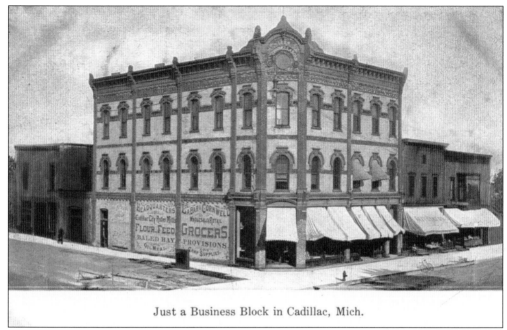

Just a Business Block in Cadillac, Mich.

Construction of the magnificent three-story LaBar & Cornwell building began in late 1884. The street-level storefront housed the LaBar & Cornwell Grocers and the Cadillac City Roller Mills, a flour and feed store. The second level provided space for offices, and the Masons, prior to the construction of the Masonic Temple, used the third level.

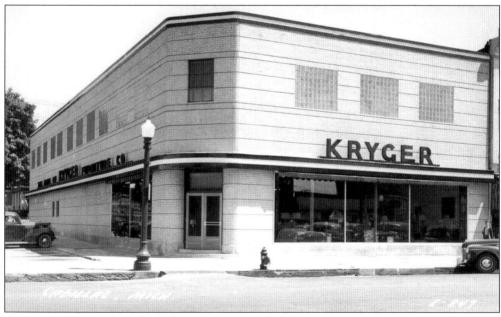

Henry Kryger acquired the Labar & Cornwell building and opened a furniture store. He remodeled the building in 1940 to modernize the facade using light-colored brick, glass block windows, and contemporary signage on both faces of the building. It was eventually razed in 1994 after a 110-year life on Mitchell Street.

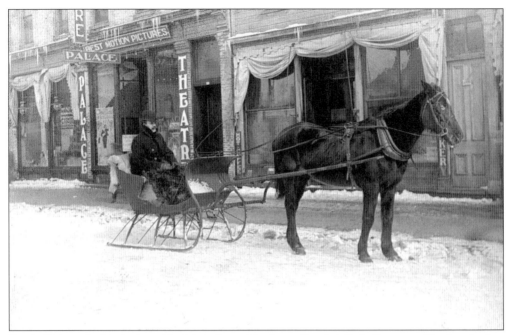

Frank Holmquist hitched up his sleigh for a ride down South Mitchell on a cold winter's day. The entrance to the old Palace Theater is shown in the LaBar & Cornwell building on the southeast corner of Cass Street.

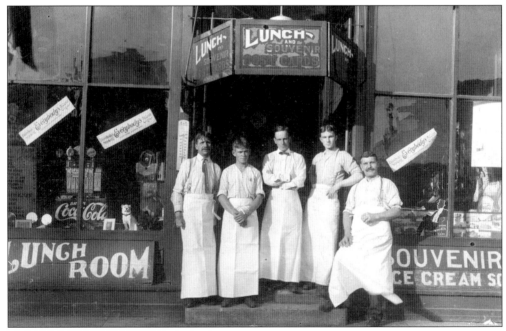

The Lunch Room, at 207 South Mitchell, was owned by Frank Holmquist, far right. In addition to lunch, customers could purchase souvenirs and picture postcards of Cadillac. Frank moved the restaurant one door south in 1918 and decided to expand his business by adding second and third floors with sleeping rooms in 1923. The establishment was renamed the Hotel Cadillac.

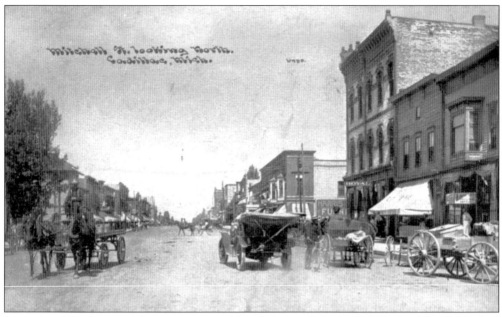

An automobile zips past delivery wagons making their rounds in the 200 block of South Mitchell Street, near Cass, c. 1909.

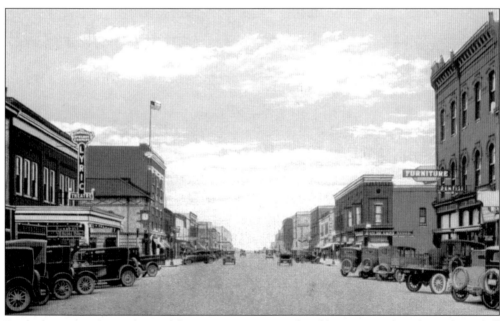

By the late 1920s, horse-drawn delivery wagons were replaced by motorized trucks, and Mitchell Street was flanked with automobiles parked at an angle at both curbs. The Lyric Theater, which was added on the southwest corner of Mitchell and Cass in 1917, displays a new vertical sign over the marquee.

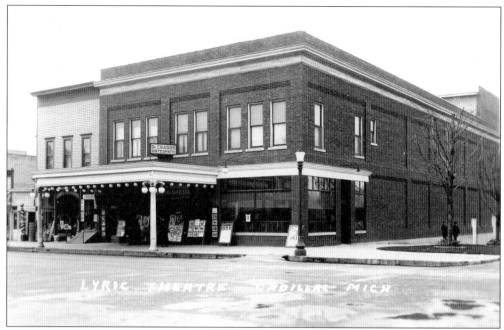

Vaudeville shows and moving pictures could be seen at the new Lyric Theater when it opened in February 1918. The building was constructed on the southwest corner of Mitchell and Cass Streets as part of the Fitzpatrick-McElroy theater chain. Special permission was granted by the City, which allowed the theater to construct the marquee over the sidewalk.

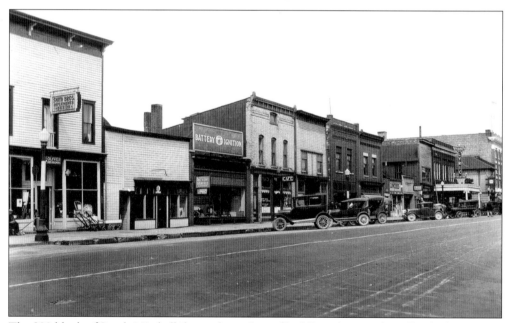

The 200 block of South Mitchell shows the variety of buildings, large and small, which occupied this segment between Chapin and Cass in the late 1920s. Shown at far left in this photo is the Smith Brothers store, which sold farm implements, horse collars, and harnesses. Johnson's Hardware, next to the Lyric Theater, operated in this location for many years.

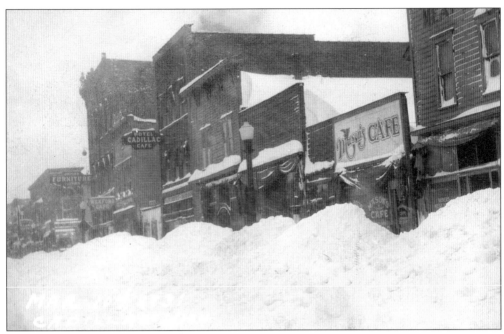

Storefronts in the 200 block of South Mitchell Street were obstructed by huge snowbanks that resulted from the blizzard of March 1931. Businesses that would have been on this block in 1931, starting from Cass Street are, as follows, Kryger Furniture, Wexford Cafe, Hotel Cadillac, James Johnston Grocers, Louis Grillo Fruits, the Mason Cafe and Rupers Meat Market.

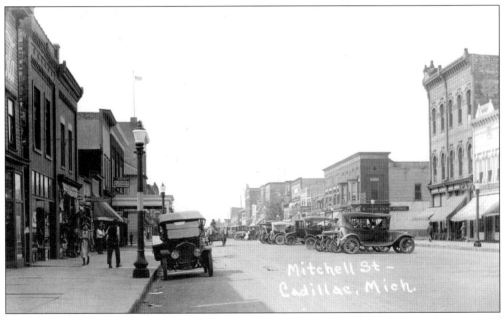

This view captures South Mitchell Street, near Cass, before angle parking in the center of Mitchell was banned in 1926. Autos were allowed to park parallel to the curb for 10 minutes if needed. This rule was strictly enforced so that horse-drawn wagons could make curbside deliveries.

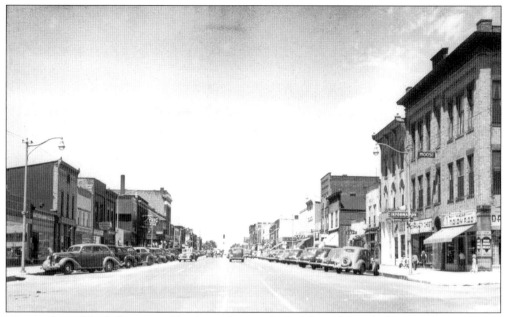

The business block between Chapin and Cass Streets has changed dramatically since this photograph was taken in the 1940s. This view in particular shows the east side of the block, when it was still a commercially active part of the downtown. The Viking Dairy Bar, located on the corner at far right, was a popular place to go after school for ice cream.

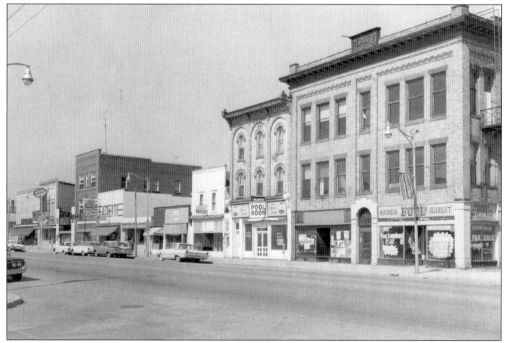

The Realty building, at far right, and the original Odd Fellows Block building next door, were razed when Oleson's Shopping Center was built in 1965. In this view from the early 1960s, it was apparent that this end of the block had seen better days.

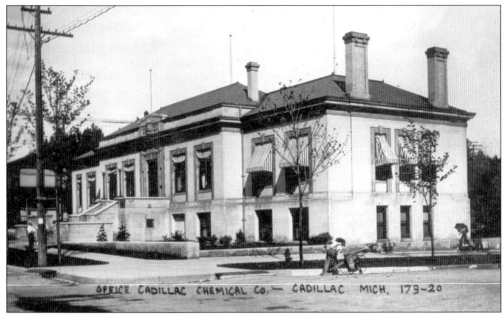

The Cobbs & Mitchell Lumber Company constructed their offices on the corner of Mitchell and Chapin Street in 1907. The exterior is described as Georgian-style and is covered in gray granite and sandstone. The interior showcases several varieties of local hardwoods with brilliant finishes throughout. The Michigan State Highway Department owns and occupies this building today.

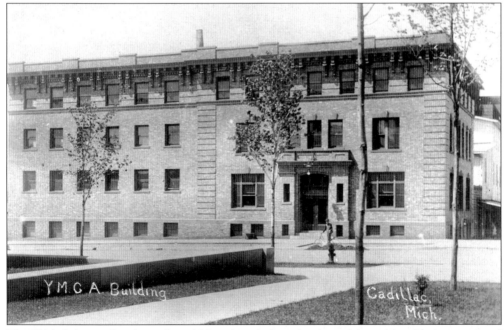

The Y.M.C.A. was the place where kids gathered after school, participated in athletic events, and attended dances. This photograph of the "Y" shows the recently completed building on Mitchell and Chapin. After it closed, attempts to revive it as a teen center were short-lived. Maintenance of the building became a liability and it was razed around 1990.

Three
BEYOND MITCHELL STREET

Although vintage postcards depicting scenes of Mitchell Street were popular and documented many of the town's landmark buildings, some of Cadillac's most historically significant places existed only a few steps beyond Mitchell Street and were also immortalized in postcard form. The Cadillac Opera House, the Wexford County Courthouse, the Carnegie Library, the Ann Arbor Railroad depot, and the City Park are but a few examples. Of those listed, the building which retains the most mystique is the elegant old Cadillac Opera House, toppled by a wind storm in 1930 and razed in 1933. For those in recent generations, those who never passed through its double-entry doors or heard the voice of an actor resonate from its stage, the Opera House will always be mourned for its unfortunate and premature demise.

Construction of the Carnegie Library and the Wexford County Courthouse were two of Cadillac's most ambitious and prestigious undertakings in their day. This was evidenced in the variety of postcard views of both buildings that were produced after they were completed.

The original Mercy Hospital is yet another subject frequently shown in vintage Cadillac postcards. Built in 1907 with funds donated by Mr. and Mrs. Delos Diggins, the addition of the hospital was a great source of pride for the growing town. Numerous postcards depicting the interior and exterior of the hospital serve as reminders that it was considered a state-of-the-art facility at the time it was built.

Other departures from the downtown include restaurants and railroad depots; everyday sights that were perhaps taken for granted, but are now fondly remembered.

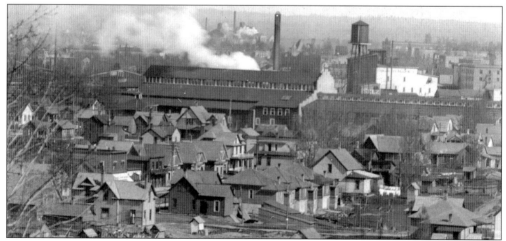

A view of Cadillac, looking north from Maple Hill Cemetery, shows the scale of the Mitchell Brothers' flooring plant in relation to the small homes in the foreground.

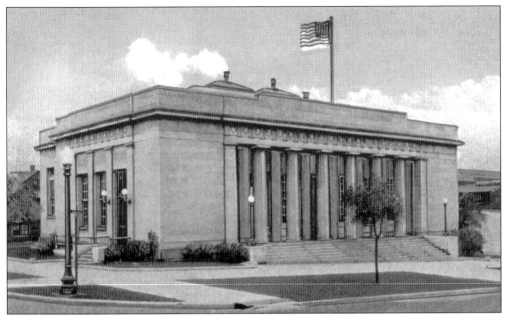

The new and substantially larger post office opened on Harris and Shelby in December 1915, replacing the smaller office on South Mitchell Street. The lawn in front of the building was eventually sacrificed for angled parking spaces, as there were apparently no provisions for parking in the original site plan.

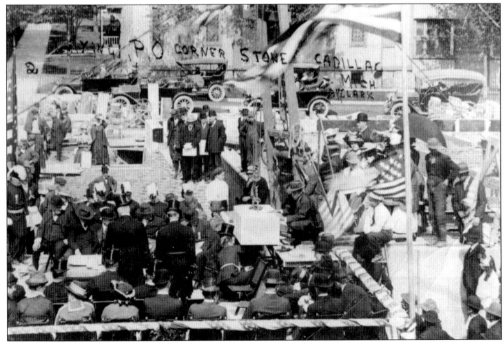

A formal ceremony takes place on May 11, 1915, as officers of the Masonic Grand Lodge of Michigan lay the cornerstone for the post office. The post office was built on the former site of the Kelly & Mather livery stable.

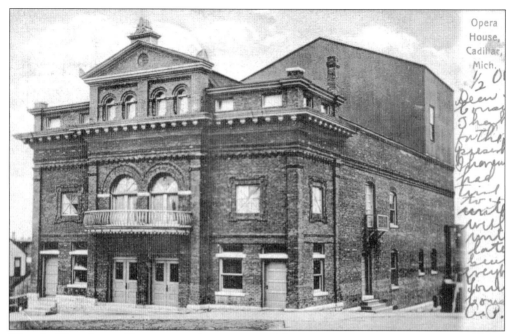

The Cadillac Opera House opened in 1901 and became the venue of choice for quality entertainment, boasting approximately 700 seats. In 1930, a wind storm destroyed the large loft on the building and sent it crashing to the stage below. Little was done to repair the damage, and the Opera House languished. It was razed in 1933.

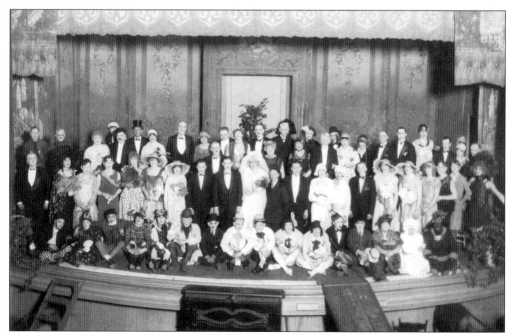

The cast of this rather large production assembles on the stage of the Opera House. In addition to hosting local civic and cultural events, the Opera House attracted many popular stage stars, vaudeville acts, musicians, and other entertainers during its heyday.

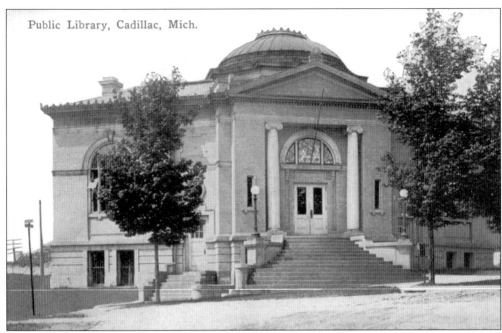

A 1907 brochure publicizing the City of Cadillac featured a photo of the new library with a caption reading, "Carnegie Library, Mecca of the Bookish." The stylish appearance of the new building was indeed a sight to behold at the top of Beech Street, with its flowing steps to the main entrance, towering columns, and decorative arched windows.

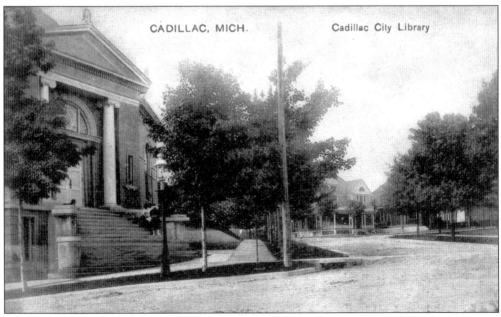

The steps from the Carnegie Library descend to the sidewalk on Beech Street, where it meets the gradual bend of North Shelby. The library occupied this building until 1969, when a new library was built on Lake Street. The Wexford County Historical Society Museum acquired the building in 1977 and now maintains exhibits on both levels.

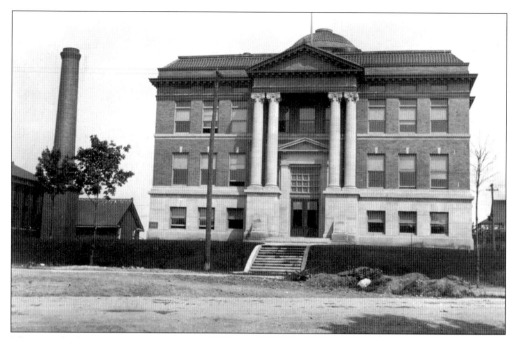

The Wexford County Courthouse is shown shortly after its completion in 1913. The pile of debris on East Division suggests that there are still some final touches to be made. Decorative lamp posts with globes were eventually placed on the pedestals near the main entrance. The courthouse is still in use by Wexford County.

The old Wexford County Jail was built next to the courthouse on East Division Street and provided living quarters for the Sheriff and his family. The main cell block was located behind the living quarters of the building, and the tall chimney rose from the large boiler room on the east side of the building. From this location, inmates could be escorted from their cells to the courthouse in a matter of minutes. The jail was torn down after the new county jail was built in the early 1960s.

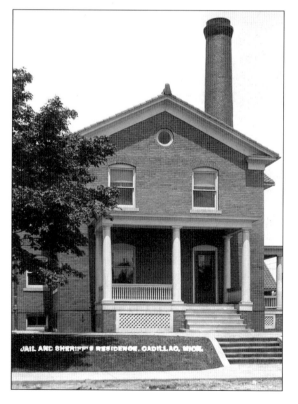

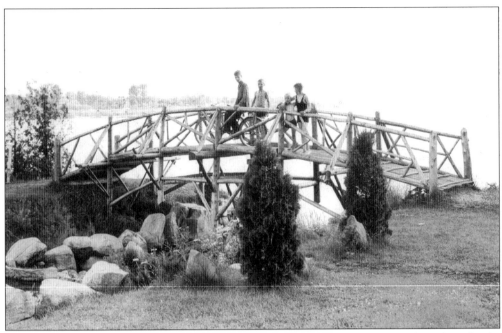

Children enjoy the view from the small wooden bridge that used to span the inlet of Lake Cadillac in the City Park. The land bordering the lakeshore in the City Park once belonged to the Ann Arbor Railroad. Several public works projects were undertaken in 1934 to improve the lakeshore area, including the construction of this bridge and inlet.

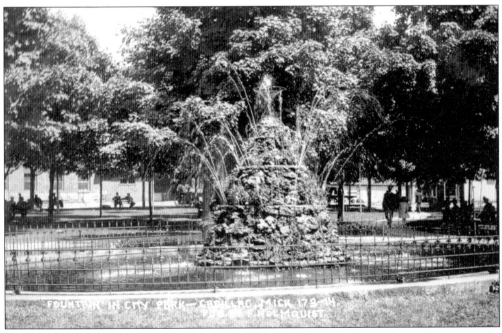

This elaborate rock fountain was added to the shallow pond in the City Park in 1905. A popular style of fountain from this era, it closely resembled a beehive in shape and had numerous spouts at different levels.

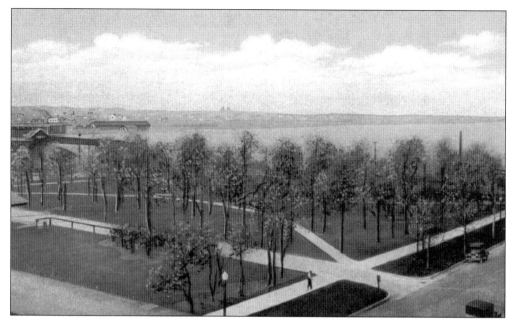

Here is a panoramic view of the City Park, overlooking Lake Cadillac and the mills along the distant shoreline, from the 1920s.

The tracks of the Ann Arbor Railroad continue past the old bandstand that once stood in the City Park. This view, looking north from the Ann Arbor depot at the foot of Cass Street, was taken before Lake Street was extended through the City Park.

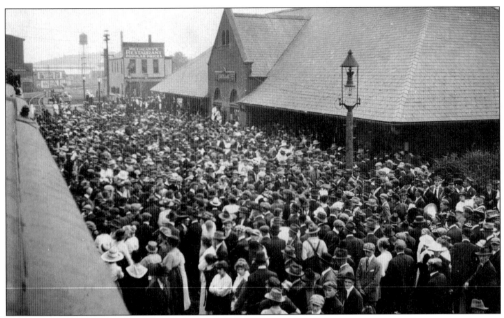

Passengers crowd the platform at the Pennsylvania Railroad depot in 1920 as the train arrives at the station. Cadillac was situated at the junction of two major rail lines and was a point of transfer for many business and resort travelers. It was reported in 1907 that 18 passenger trains stopped in town every day. Passenger trains were discontinued in the early 1950s.

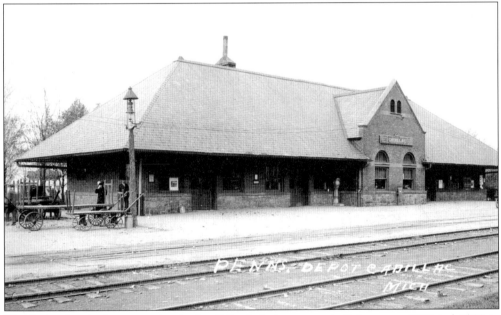

The Pennsylvania depot, previously the G.R. & I. depot, was built between 1899 and 1900 to replace its wooden predecessor. Described as a "commodious" structure, the depot stood just east of the City Park and offered amenities to the weary passenger, including a restaurant and spacious women's lounge. The depot was razed in the 1950s to create parking for the downtown.

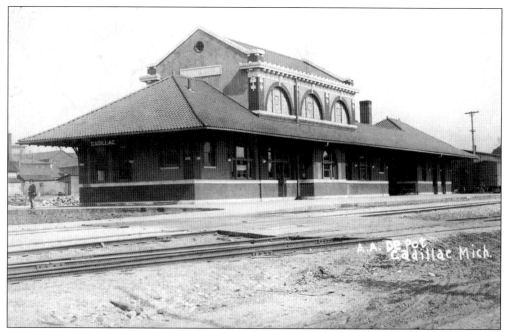

Construction of the Ann Arbor Railroad depot in 1911 answered Cadillac's needs for additional rail passenger facilities. The City allowed Ann Arbor to build the depot at the foot of Cass Street in exchange for the lakefront property south of the city dock. The depot still stands as a reminder of Cadillac's once-bustling rail passenger days.

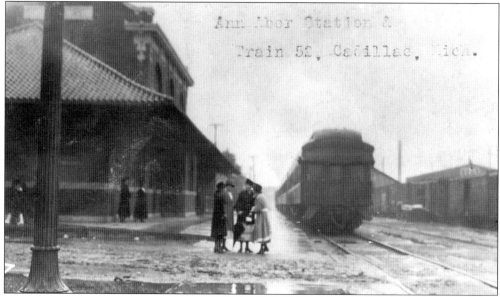

Outside the Ann Arbor Railroad depot on a rainy morning in 1919, ladies visit as they await the boarding of train 52, standing on the tracks nearby.

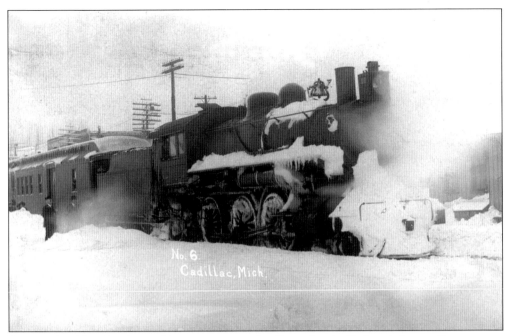

Locomotive No. 6 arrives with passengers at the Pennsylvania Railroad depot after a snowy journey from the north.

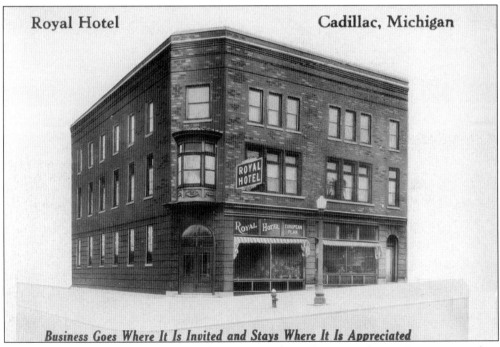

The Royal Hotel, located on West Harris across from the Pennsylvania Depot, catered to traveling salesmen requiring overnight accommodations. The hotel was equipped with a restaurant, but suspended meal service during World War II. Fire later gutted the hotel and it never reopened. The building was salvaged and remodeled for use by the Cadillac State Bank.

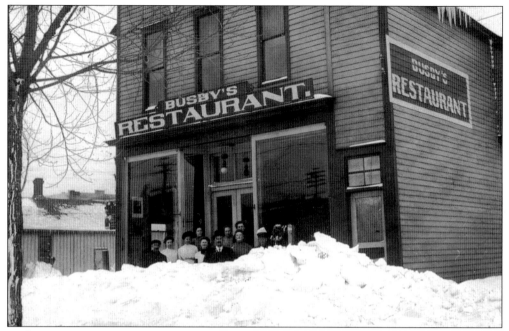

Busby's Restaurant was conveniently located on West Cass, across the street from the Pennsylvania depot. Hungry passengers and railroad employees could drop in for a meal and continue on their way.

This wading pool, located at the foot of Cass Street, was another improvement made as part of a public works project to beautify the land given to the city by the Ann Arbor Railroad. This photo, taken in 1942, shows Judy Firkins, standing second from the left. The pool was removed sometime in the mid-1940s.

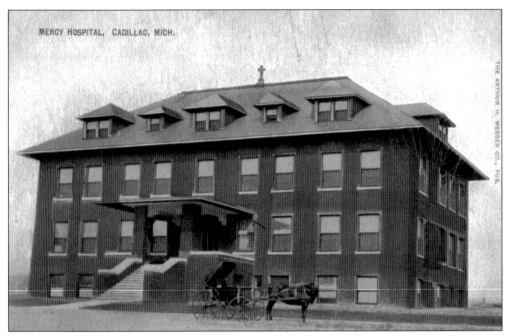

A carriage is parked at the front entrance to Mercy Hospital on Oak Street. Built in 1907 with a generous financial contribution from Mr. and Mrs. Delos Diggins, the three-story facility also had a basement level. It opened in January 1908. The hospital was administered by the Sisters of Mercy and had a total of thirty beds.

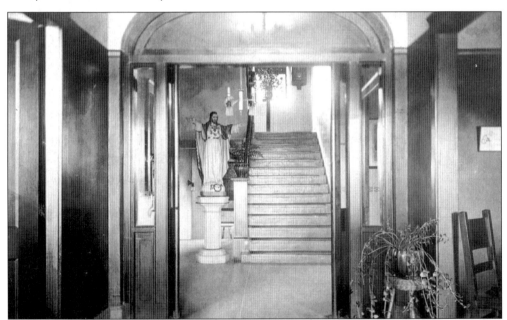

"The first floor proper is a splendid example of architectural conception. The spacious reception hall, the stairs in the distance leading to the second floor, the parlor to the right with its rich yet simple furniture. . .produce on the mind a sensation of peace and repose." This statement was printed in the Mercy Hospital Report, 1908–1911.

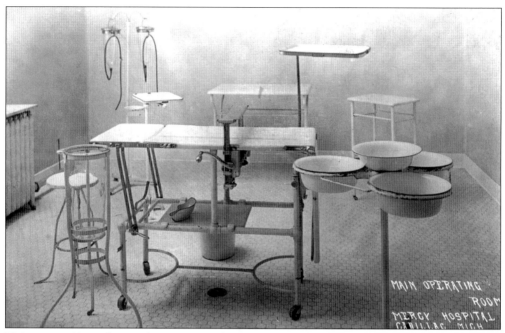

This composition of surgical apparati was thoughtfully arranged to convey a hygienic atmosphere in the main operating room of the new hospital.

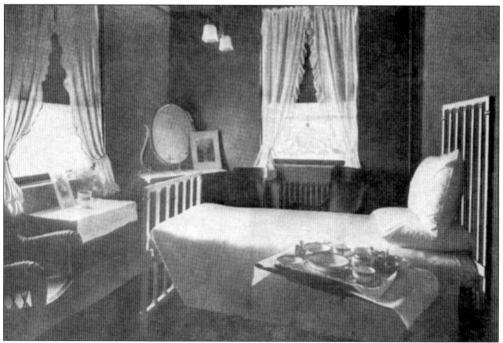

Patients who wanted to avoid crowded and impersonal ward rooms could splurge for this well-appointed private room, costing between $10 and $25 per week, not including doctors' visits or medication. Each room had its own tea service and was situated to benefit from healthy doses of light and fresh air.

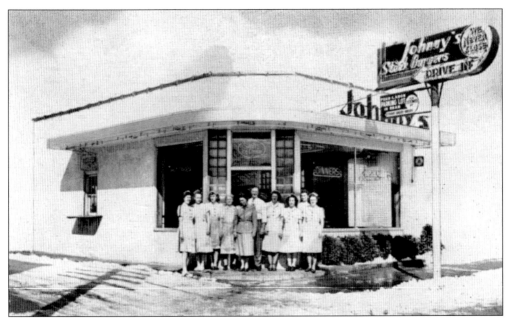

Johnny's Steak Burgers, or simply "Johnny's," boasted the first drive-in window in northern Michigan and was a popular place to go for coffee after dates and dances at the "Y." Herb Johnson opened Johnny's at 902 South Mitchell in 1946, and it became Cadillac's favorite late-night rendezvous for many years afterward.

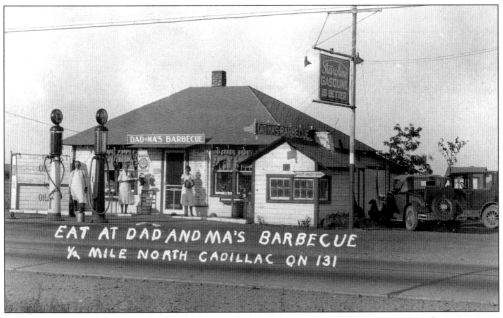

A classic example of roadside America in Cadillac, Dad and Ma's Barbecue was a welcoming oasis for travelers north of town on US 131. For motorists who were just passing through, a large sign posted next to the entrance listed the number of miles to other Michigan destinations. Dad and Ma's later became the infamous Beacon Bar.

Four
Lumbering and Early Industry

Cadillac's industries consist of six lumber mills, three planing mills, two flooring plants, a 125-ton charcoal iron plant, two chemical and charcoal plants, a last block factory, [a] veneer and basket works, a handle factory, a crate factory, [an] iron works and machine shop, [a] cooperage stock mill, [a] collar factory, six cigar factories, [a] brickyard, two grist mills, [a] table factory, [a] cabinet works, and at least twenty smaller institutions employing from half a dozen to twenty-five hands.

—North Central Michigan Yearbook, Howard-Packard Land Co., 1907

Postcards depicting industrial Cadillac after 1900 illustrate the enormous impact that the lumber industry once had on the community. Today, it's hard to imagine that sawmills, chemical processing plants, and lumber yards once flanked the entire east end of Lake Cadillac.

A brief inventory of Cadillac's industries in 1906 accounted for a total of 30 factories employing 1,660 hands. Although the lumber industry was still active in the early 1900s, the remaining stands of white and Norway pine were rapidly diminishing. By this time, lumber manufacturers had already begun to shift their focus away from processing softwoods and turned instead to the processing of hardwood products such as flooring, furniture, broom handles, and folding fruit crates. It also became apparent that the remaining hardwood stands in the area would not last forever. Industrial diversification would be necessary to ensure the future economic survival of the town.

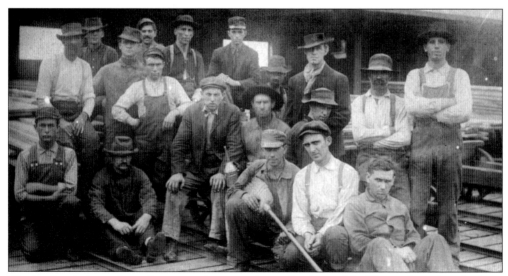

The lumber industry brought economic prosperity to the City of Cadillac and employed a large percentage of the town's population. Mill workers gathered for this group portrait on the tramway inside the lumber yard.

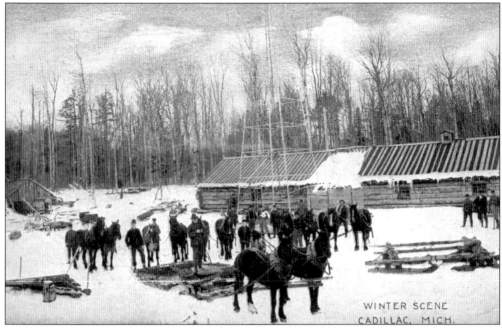

A winter scene at this unidentified logging camp shows a crew of skidders preparing to hitch horse teams to empty logging sleighs in preparation for a long day's work.

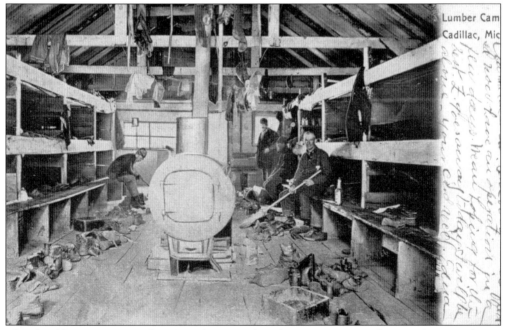

This bunkhouse interior illustrates the typical and rustic accommodations that woodsmen encountered in lumber camps. Personal belongings are shown strewn about the floor and scattered across rows of bunk beds. The large wood stove in the foreground provided heat for the bunkhouse during colder months.

A lone woodsman, poised with axe in hand, takes a break from cutting small branches off recently cut timber.

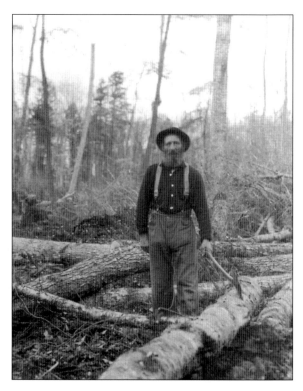

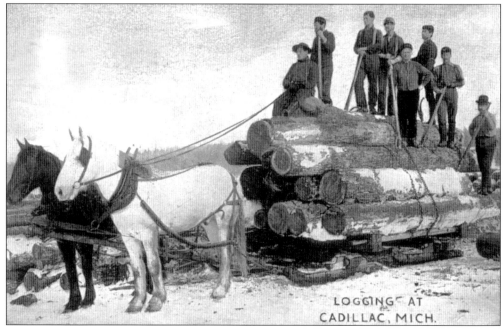

Logging sleighs, pulled by teams of horses, provided the most common means of removing timber from the woods during the winter. The sleighs hauled it to various collection points, or "sidings," along the railroad spurs. Logs were secured to sleighs using sturdy chains, while skidders often hitched a ride atop the load.

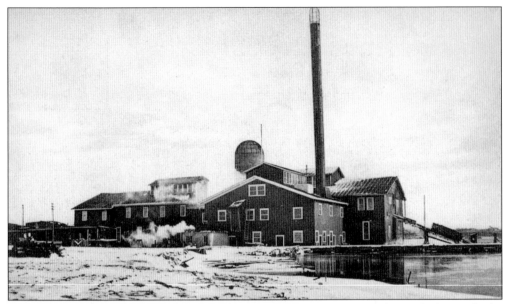

The Cobbs & Mitchell Lumber Company operated two sawmills along the south shore of Lake Cadillac. Mill No. 2, pictured above, processed pine and hemlock with a total production capacity of 90,000 feet per day. Mill No. 1, the smaller of the two mills, processed hardwood products only.

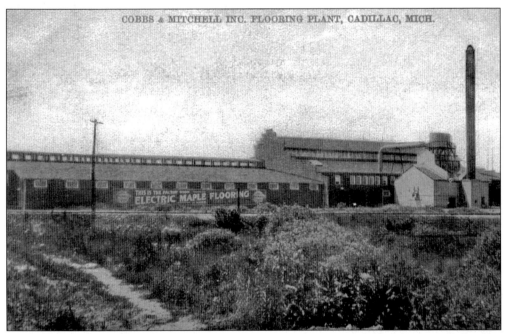

"This Is The Factory Where Electric Maple Flooring Is Made," reads the sign on the Cobbs & Mitchell flooring mill, located where the Cadillac Square Shopping Center now stands. One of the two largest flooring plants in the world, it occupied a 200 by 600 foot area and operated eight flooring machines. An electric generator powered the smaller machinery and supplied the lighting.

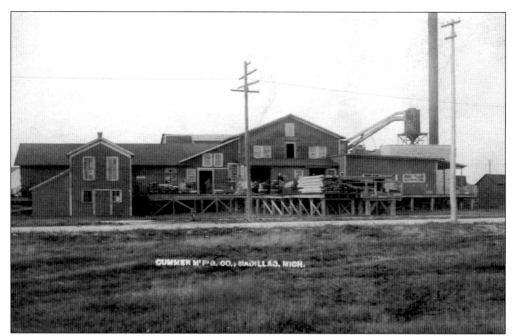

Renowned for the manufacture of inventive wood products such as the Humpty Dumpty egg crate, folding fruit crates, and ladders, the Cummer Manufacturing Company began operations in 1885. The company originally started out processing pine lumber, but later focused on hardwood products as the supply of softwood began to dwindle in the region.

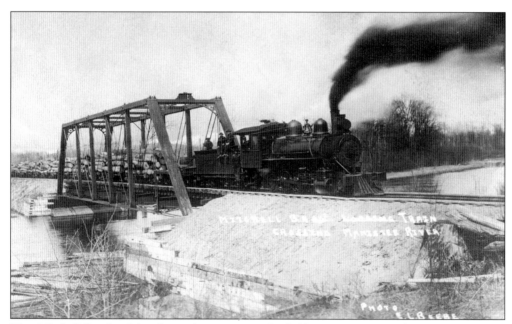

The Mitchell Brothers' logging train pauses on the bridge crossing over the Manistee River. Locomotives that were specifically designed for the logging industry, such as the Shay, could transport logs from remote areas and over difficult terrain.

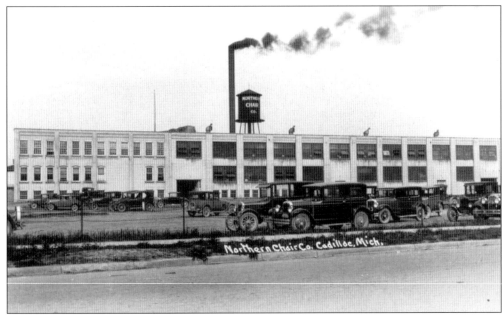

The Northern Chair Company, located at the intersection of Seventh Street and First Avenue, stood next to the St. Johns Table Company. Sometimes mistaken for St. Johns in photographs, this 1920s view shows the large factory and employee parking lot.

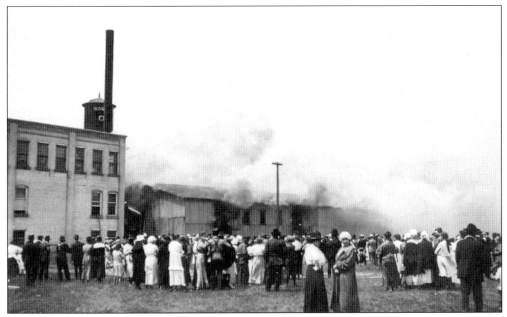

Spectators gather as fire destroys the warehouse of the Northern Chair Company on June 20, 1918. It was also reported that the office was damaged in the blaze. The sprinkler system, however, saved the day and the rest of the factory survived intact.

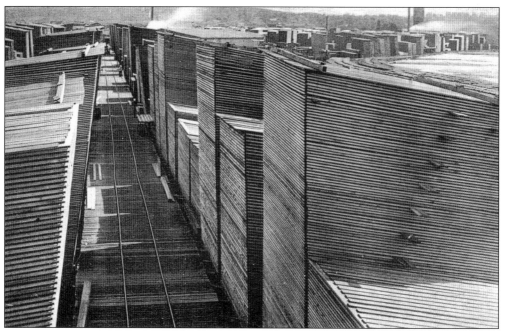

Milled pine boards were carefully stacked at angles in the lumber yard so that rain and moisture would drain properly. "Lumber alleys" were created as large stacks of lumber were placed in rows along the tramway.

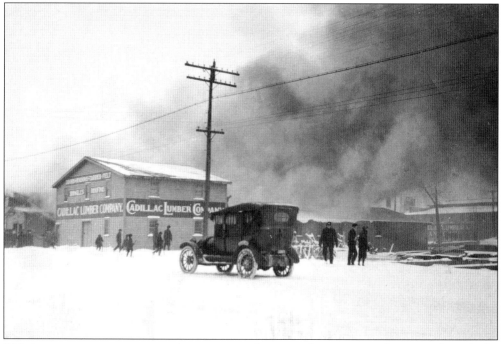

This is not a great way to start the new year. A commotion ensues as fire rages through the warehouse and office of the Cadillac Lumber Company on January 1, 1918. The fire raged for twelve hours in freezing weather and the damage was estimated to be over $15,000.

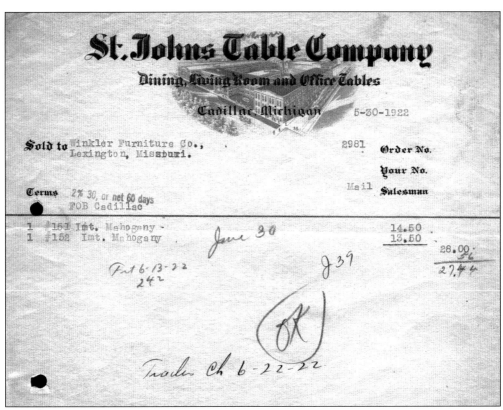

An early invoice from St. Johns Table Company recorded the sale of mahogany to the Winkler Furniture Co. in Missouri for a total of $27.44.

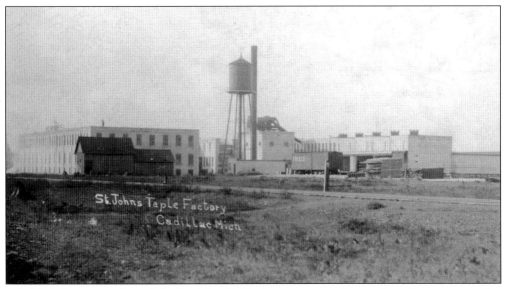

A behind-the-scenes view of the St. Johns Table Company reveals several smaller structures that were overshadowed by the main plant. These included the engine room, lumber storage facilities and the small oil house at the base of the 30,000 gallon tank.

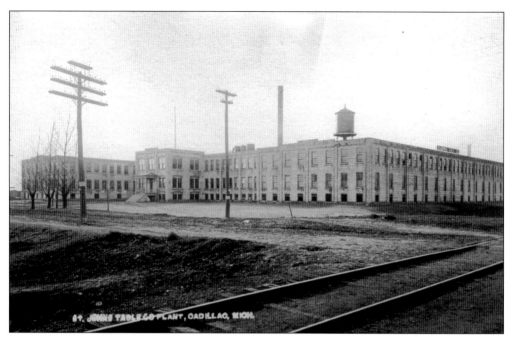

A shortage of hardwood resources in southern Michigan prompted the St. Johns Table Company to relocate to Cadillac from St. Johns, Michigan in 1905. This enormous factory complex was constructed north of town on Gunn Street between two major railroad spurs. St. Johns was reported to have been the world's largest factory to exclusively produce tables.

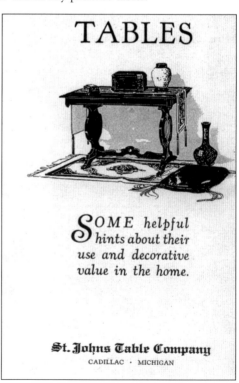

"A well appointed room is never crowded with miscellaneous furnishings. Every principal piece should have a definite reason for location. Massive tables are rather out of favor, and entirely out of keeping in a small apartment or house. Instead have come into favor the narrower davenport types, delicate in design and equal in utility." Helpful advice, regarding the latest trends and some errors to avoid in the selection of small tables, was offered in this concise and wonderfully illustrated brochure produced by St. Johns Table Company.

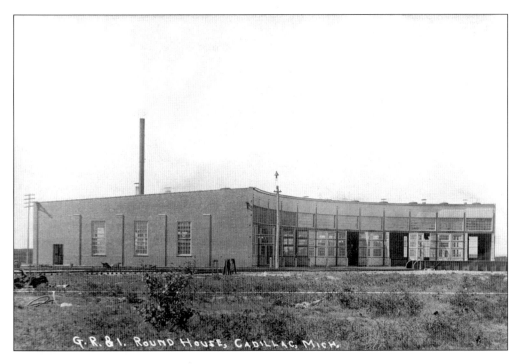

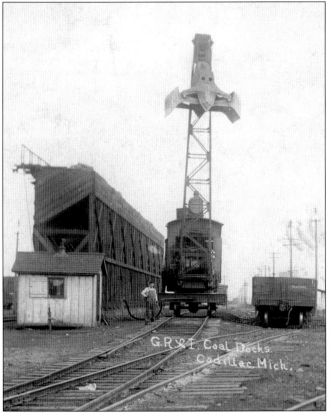

Locomotives were serviced after a day's run at the G.R. & I. roundhouse on the southeast corner of Haring (now North Mitchell Street) and 13th Streets. A large turntable was located outside the entrances to the service stalls. After the roundhouse became obsolete, the large turntable was sold for scrap. The site later became the Roundhouse Lumber Company.

This steam-powered crane, outfitted with a clam-shell bucket, was used to load coal into the coal cars of locomotives at the G.R. & I. coal dock. The dock was completed at the intersection of Haring and 13th Street in 1906. The G.R. & I. roundhouse was built across the street in 1911.

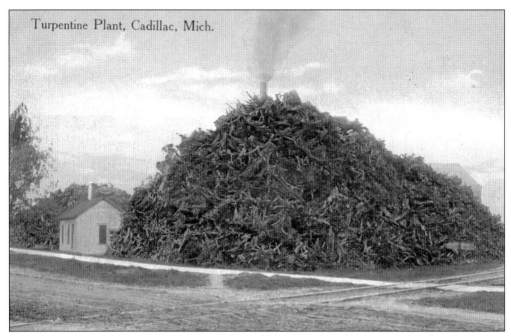

A curious sight, mountains of pine stumps could be found at the turpentine processing plant north of Haynes Street near the Clam River. Stumps were brought to the site by the wagonload as pine trees were cleared from the forests.

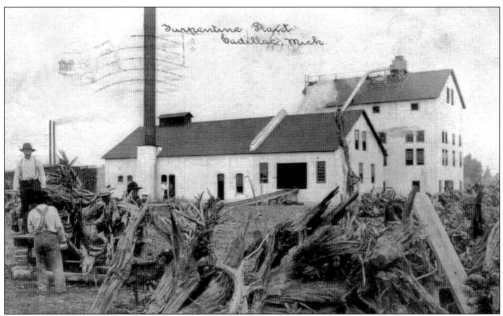

Plans to construct a turpentine plant in Cadillac arose from the desire to convert the large quantities of locally generated pine by-products into a lucrative business. The plant, which opened in 1908, operated profitably until 1915, when embargoes on exports to Europe during World War I caused a glut in the U.S. marketplace. Operations ceased shortly thereafter.

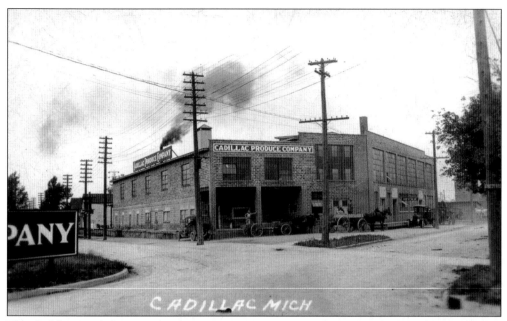

The Cadillac Produce Company began operations in 1916 after purchasing the former Swift & Co. buying station at Lake and Pine Streets. Beatrice Creamery Co. acquired the Produce Company in 1930. In 1956, Kraft Foods moved to the site. This photograph shows a rare view of the building when it had two stories. A severe wind storm collapsed the second floor in 1940.

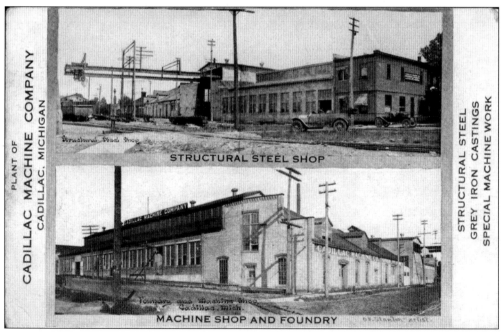

The Cadillac Machine Company began operations at this plant in 1901. It was the former location of William McAddie & Co. on Lake Street between Harris and Mason. A partnership of Walter A. Kysor and Frank L. Farrar, the Machine Company manufactured steel-lined charcoal cars and triple-deck bunk beds. They also performed repair work on local lumber mill machinery.

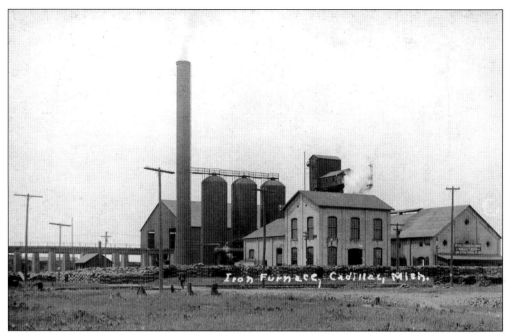

Charcoal, a plentiful by-product of local wood-processing chemical plants, was used in the smelting of iron ore at the Mitchell-Diggins Iron Furnace from 1906 until 1927. Spectators often gathered to watch glowing liquid metal flow from the gigantic pot as it was tipped to fill the molds below. The Malleable Iron Company was built next door in 1922.

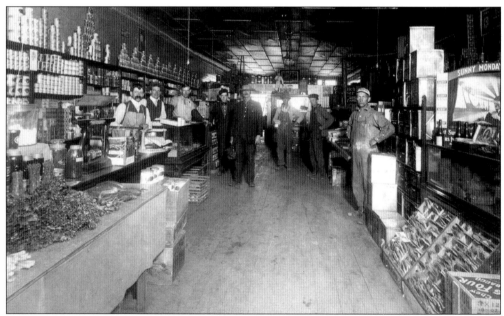

This photo of an unidentified company store in Cadillac, most likely run by one of the lumber companies, shows employees and customers lingering in the well-stocked interior. Note the large produce scales on the counter at the left, and the carefully arranged canned goods on shelves along the back wall.

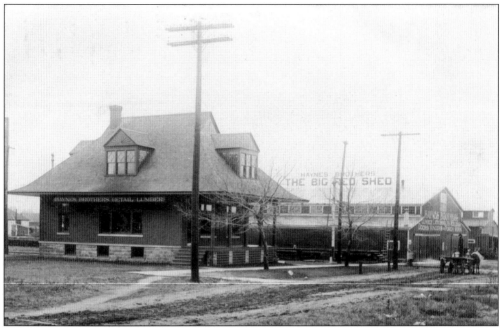

"Home of the Big Red Shed," the familiar slogan used by the Haynes Brothers Lumber Company, aptly described the huge red lumber storage shed at the foot of Chapin Street. The building in the foreground resembling a small depot was the office of the lumber company and still stands today.

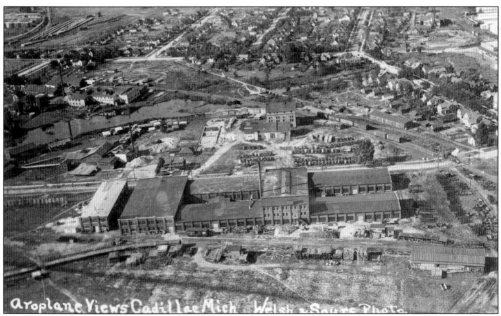

An early aerial view of the vicinity of Haynes Street and the Clam River shows the vast array of industrial buildings in this neighborhood. The large complex in the foreground was built by the Acme Motor Truck Company in 1917 and has been occupied by different manufacturing companies over the years.

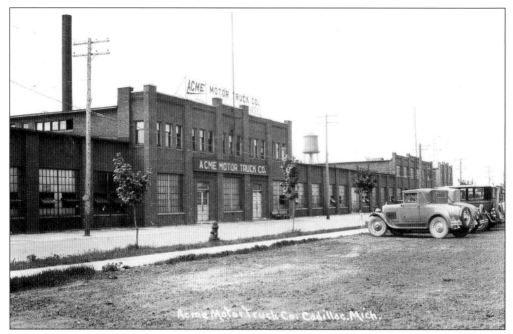

This large manufacturing facility on Haynes Street, just west of the Lake Street intersection, was built by the Acme Motor Truck Company in 1917. After several profitable years in business, the plant closed its doors in 1932 due to financial difficulties. The B.F. Goodrich Company moved to Cadillac in 1937 and operated in this facility until the late 1950s.

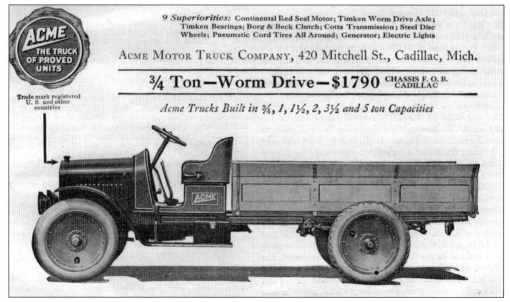

This is a portion of a large advertisement featuring the three-quarter ton Acme Speed-Truck, which appeared in a 1921 issue of the Literary Digest. In addition to flatbed utility trucks, the Acme Motor Truck Company manufactured a full line of units: mail delivery trucks, fire trucks, dump trucks, and sixteen-passenger coaches.

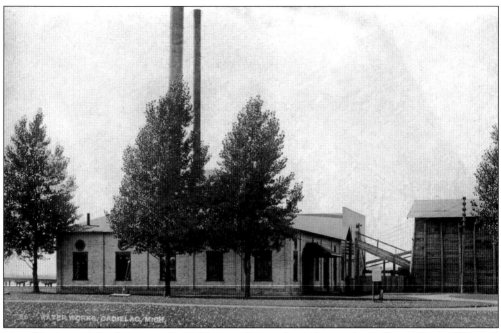

The old water works plant, complete with towering smokestacks, was located on Lake Cadillac, just west of the Lake and Pine Street intersection. Standing to the right of the plant is the shavings bin of the Murphy & Diggins sawmill. Wood shavings were used as fuel to power the water pumps.

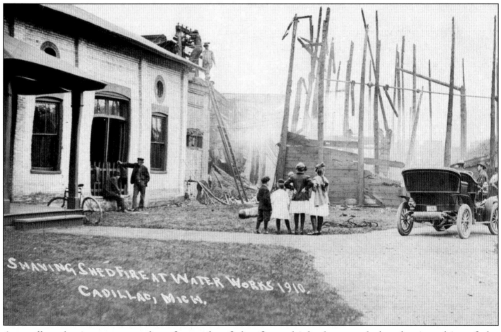

A small gathering surveys the aftermath of the fire which destroyed the shavings bin of the Murphy & Diggins sawmill in 1910. The water works plant at the left was not seriously damaged and continued normal operations afterward.

Five
THE GREAT ICE STORM OF 1922

Although it is not uncommon for heavy snowfall to occur throughout the winter in northern Michigan, the ice storm which hit Cadillac and the surrounding region on February 22, 1922 (2/22/22), was unlike any storm ever experienced in the town's brief history. As trees and utility poles collapsed under the weight of the dense icy glaze, streets became inaccessible and telephone services and electricity were lost for several days.

Despite the obvious complications that were caused by this storm, it was also a curiosity to behold. As residents ventured from the safety of their homes the following morning to survey the damage, local photographers took to the streets and captured the unbelievable sights around town and across Lake Cadillac. Their endeavors resulted in a series of postcards that could be mailed or kept as mementoes illustrating the severity of Cadillac's worst weather-related disaster. The number of different ice storm postcards that were printed is incalculable, and new images are continually discovered by collectors. Many of the images depicting the Great Ice Storm were taken on side streets and other obscure locations not typically shown in vintage postcards of Cadillac.

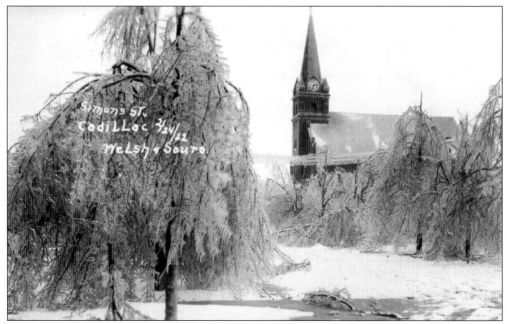

An eerie calm looms over the city after the worst storm in Cadillac's history. The Swedish Lutheran Church overlooks the fractured trees and lifeless streetscape of North Simons.

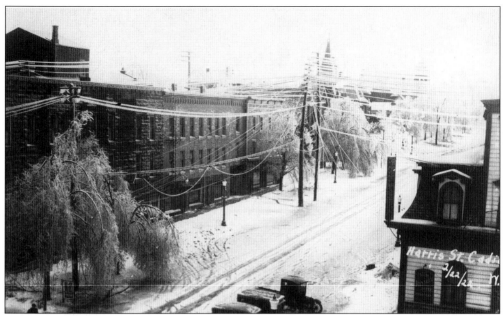

The upper level of the Webber Block building offered this birds-eye view of the storm's effects at the intersection of Harris and Mitchell Street. The roof of the Russell House (formerly the American House) is visible on the right and the McKinnon House Hotel and storefronts that face Harris Street are on the left.

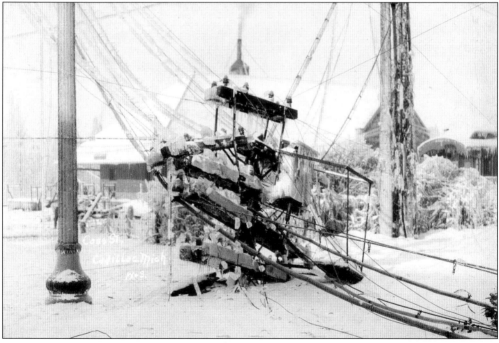

The top of a utility pole crashed to the sidewalk near the alley on West Cass Street. In addition to the danger of severed power lines around town, Cadillac also endured the loss of electricity and telephone service for several days.

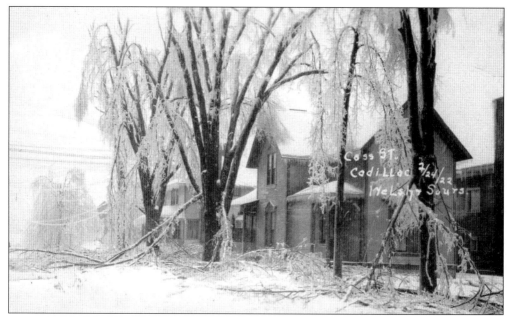

Looking south on Simons from the corner of Cass, the roadway is littered with large branches that block access to the streets from all directions.

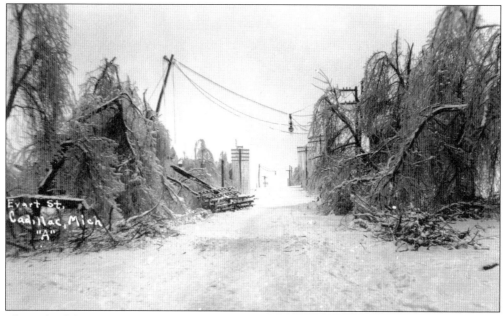

The path of destruction continues up Evart Street past this particularly mangled area. The utility pole and large tree branches gave way as the ice accumulated during the overnight storm.

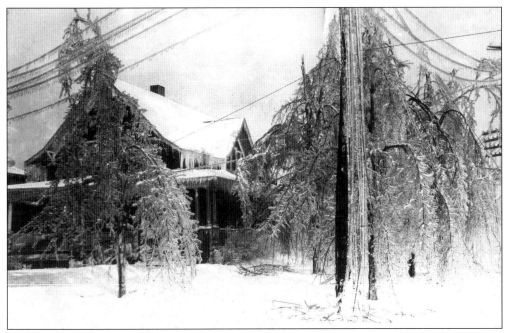

The former H. Chris Jorgensen residence, on the corner of East Division and Blodgett Streets, is visible behind the glazed ruins of trees and downed power lines.

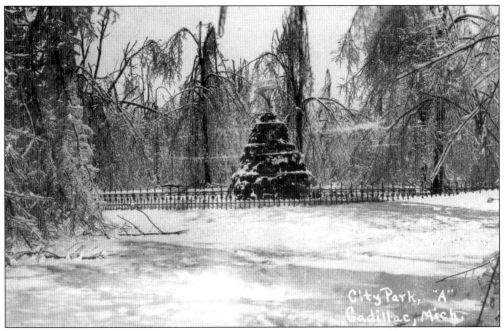

The stone fountain and iron fence in the City Park are the only recognizable elements amongst the toppled trees. A longtime Cadillac resident who was a young girl living in Tustin at the time of the ice storm likened the noise of breaking branches to the sound of a shotgun.

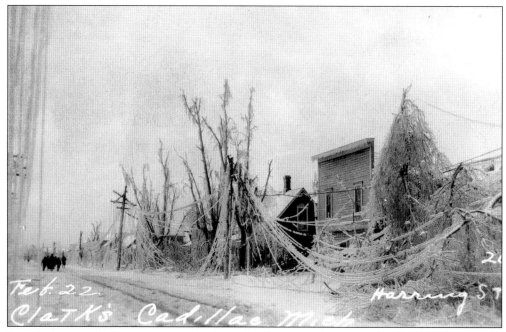

Ruts in the snow indicate that motorists have already ventured out into the elements the morning after the storm. Haring Street (misspelled in the postcard caption), later renamed North Mitchell Street, also experienced significant damage.

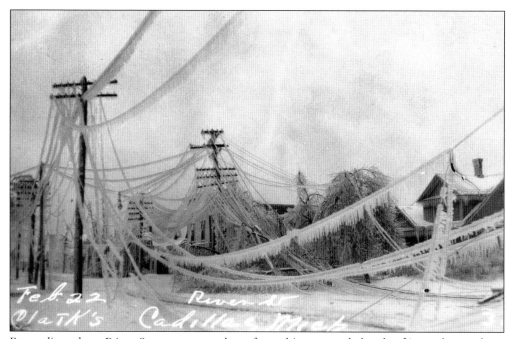

Power lines along River Street appear to have formed into a tangled web of ice and many have snapped like strands of thread.

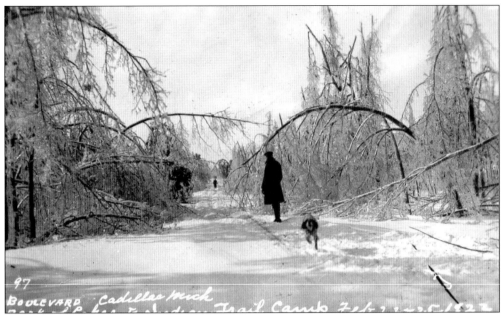

Along Boulevard Drive, between the Park of the Lakes Resort and Indian Trail Inn, trees bow under the extreme weight of the ice to create an almost tunnel-like illusion.

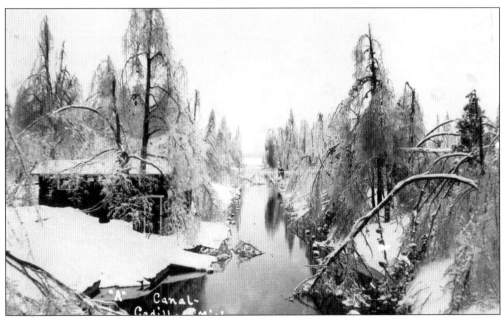

This exceptionally dramatic image of the canal, taken from the bridge looking east, caught the photographer's eye for obvious reasons. The possibility of capturing scenes such as this one provided the incentive to wander outdoors in the ice and snow with camera in hand. The structure shown near the canal was the Park of the Lakes canoe livery.

Six
Personalities and Parades

During the era when the popularity of picture postcards peaked in the United States, Cadillac was fortunate to claim several local photographers who excelled at their craft. Group portraits, snapshots of local events and of noteworthy personalities, such as Ad Wolgast, Lightweight Champion of the World, and the friendly image of every kid's favorite street vendor, Popcorn John, were popular subjects for postcards and could be readily and inexpensively produced using photographic processes.

Some of the most interesting vintage Cadillac postcards depicting the town's residents are part of the Peace Parade series, a celebratory parade which occurred on November 14, 1918, three days after the end of World War I. Residents of the town rallied to assemble elaborate victory floats and display Old Glory up and down the length of Mitchell Street.

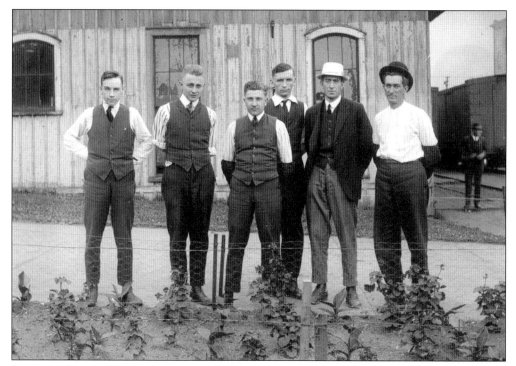

A group of gentlemen stands in front of a small garden which has been planted on West Mason Street. Train cars on the Pennsylvania railroad tracks, as well as one railroad employee, can be seen at far right.

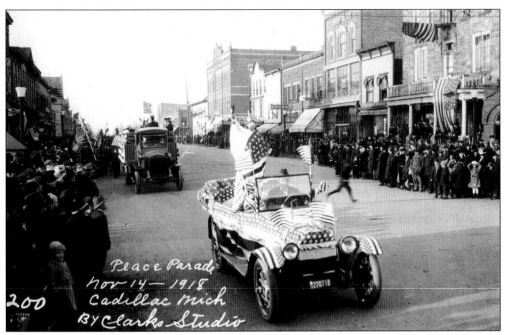

This picture dates back to November 11, 1918, Armistice Day. World War I is over and it's time to celebrate. Three days later, Cadillac residents rallied to assemble the lively and colorful Peace Parade, which extended from the Y.M.C.A. to the Clam River and back. Photographs of this event translated into a highly collectible series of postcards produced by Clarks Studio.

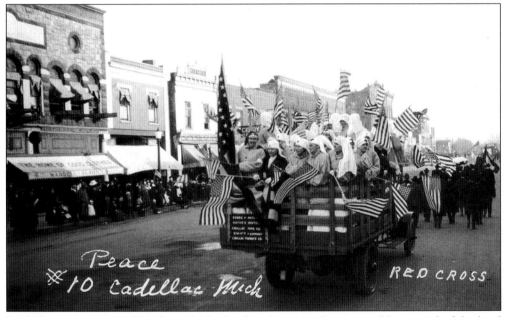

Red Cross nurses wave flags from the back of an Acme truck sponsored by several of the local lumber yards. The float is passing the Granite Block building as the parade progresses down South Mitchell Street. Note that the postcards in the "Peace Parade" series are numbered for identification, but not in any logical order.

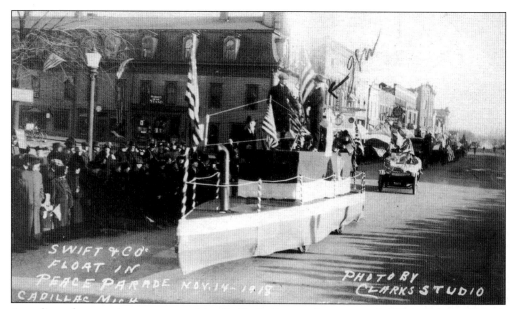

A replica of a steamboat, sponsored by Swift & Co., navigates past the intersection of Harris Street. This postcard was sent by one of the men riding on the "deck" of the float. The large three-story Russell House hotel with the mansard roof can be seen behind the crowd.

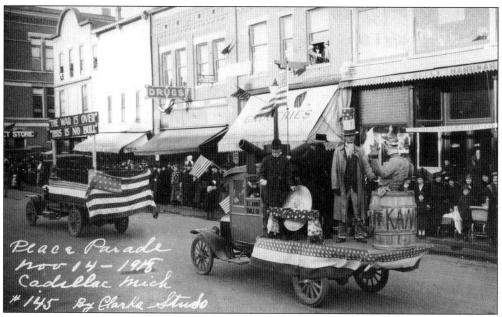

The float in the foreground was sponsored by the St. Johns Table Company and shows a caricature of Uncle Sam standing over an effigy of the Kaiser (captured in the barrel) exhibiting a gesture of surrender. This scene was photographed in front of the Drury Block Building on North Mitchell Street.

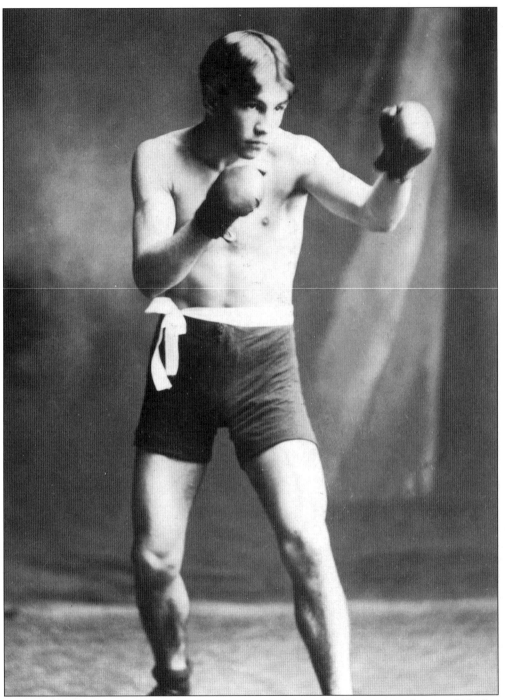

Ad Wolgast earned the title of Champion Lightweight of the World in 1910 at the age of 22 after defeating opponent Battling Nelson in 40 rounds. This postcard, depicting the young Mr. Wolgast, was sent as an invitation to a celebratory dinner in honor of Ad's victory. The event, which took place on March 9, 1910, at the McKinnon House Hotel, featured an elaborate six-course dinner and music by Borst's Orchestra.

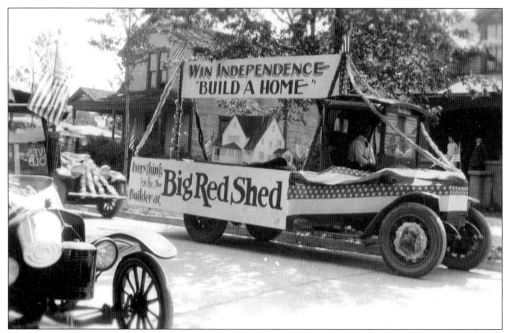

This flatbed truck advertises Haynes Brothers Lumber Company, "Home of the Big Red Shed." Although this postcard lacks a caption, it appears as though this float has been decorated for a Fourth of July celebration parade.

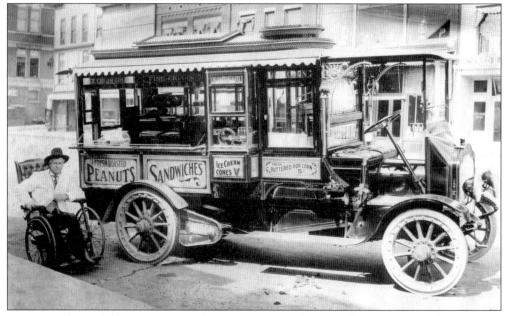

Popcorn John and his wagon were fixtures on Mitchell Street for many years. Permanently injured while helping the wives of two wealthy businessmen regain control of their runaway buggy, John was rewarded for his efforts with this elaborate and expensive motorized popcorn wagon. Popcorn John's wagon often appeared in postcard views of Mitchell Street while parked in front of Peoples Bank.

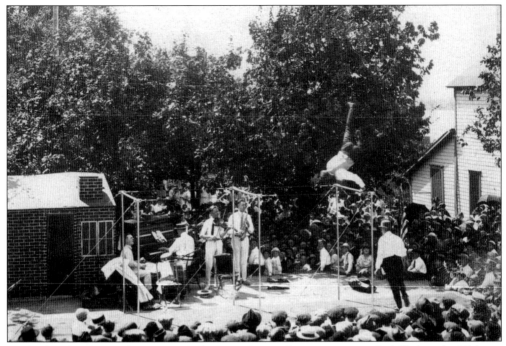

Richard and Oscar Holmen, an acrobatics and comedy team commonly billed as the Holmen Brothers Comedy Bar Artists, perform their routine as the crowd looks on. As depicted here, the performance was accompanied by a quartet of musicians.

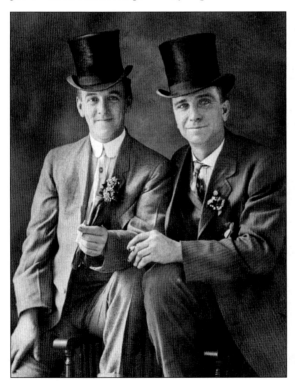

The Holmen Brothers gained international notoriety for traveling throughout the United States and Europe with the circus and performing in front of royalty. They were also well-known locally for building the Park of the Lakes pavilion on the canal between Lake Cadillac and Lake Mitchell in 1917.

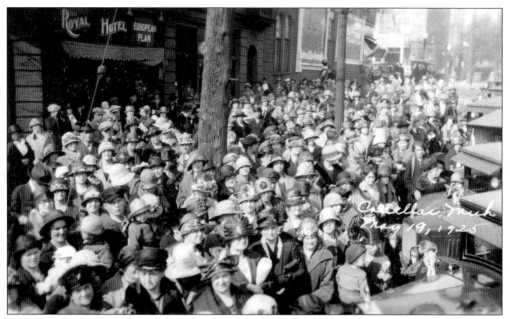

A throng of well-dressed women make their way down West Harris Street, past the Royal Hotel. Although there is no information pertaining to the event shown above, the caption reads May 19, 1925, which would have been a Tuesday. Perhaps this was a belated Mother's Day celebration?

Joe Garneau and his old grey horse are challenged daily by the unpaved streets along his general delivery route in Cadillac.

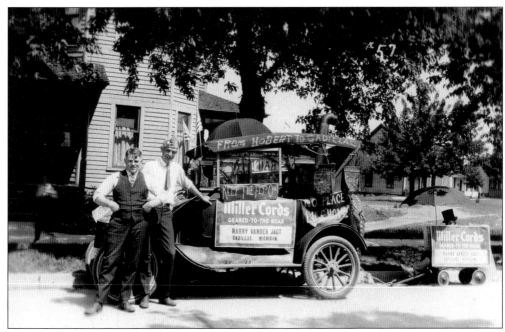

Harry Vander Jagt, on the left, and an unidentified partner stand beside their float, which has been decorated with flags, posters, and small signs with hand-painted slogans. The large posters on the side of the auto and small wagon advertise Miller Cords, a brand of tires sold by Mr. Vander Jagt in his automotive supply store on North Mitchell Street.

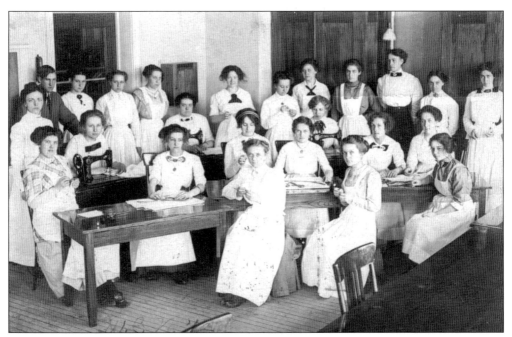

This postcard was mailed in 1912 by Bertha, one of the women pictured above, to her sister in Boon, Michigan. Although the photograph lacks a descriptive caption, it is likely that these women were taking part in a sewing class.

Seven
STREETS AND RESIDENCES

Every good citizen takes just pride in the community in which he lives, but we believe the citizens of Cadillac have greater reason to be proud than do those of most other cities. Sociology teaches us that the fundamental institution of society is the home, and the peace, happiness, and prosperity of any community can always be judged by the condition of its homes. Judging by this criterion, you will be obliged to admit that Cadillac is the happiest and most prosperous city of its size in Michigan.
—North Central Michigan Yearbook, Howard-Packard Land Co., 1907

Cadillac is synonymous with charming homes, which seem to punctuate nearly every corner of the older residential areas in town. It is only fitting that a community which reaped its early fortunes from the lumber trade would, in turn, reciprocate with residences that showcase the finest examples of architectural design and craftsmanship. This chapter represents a tour of Cadillac's residential streets and treasured homes that were idealized as postcard images in the early 1900s. Although some of the homes fell victim to the advances of commercialization and the need for additional parking off Mitchell Street, the majority of the town's most prized gems survived the twentieth century intact. Many of the homes featured in this chapter were situated only a few blocks from downtown on Cadillac's most historically significant streets: Harris, Cass, Chapin, and East Division.

Shelby Street, still unpaved in this 1909 photograph, begins its gradual slope as it continues northward past the W.W. Mitchell residence on the corner of Cass, and the Congregational Church on the corner of Harris. The original bricks used to pave Shelby Street are still visible between Beech and Harris Street, and have never been covered.

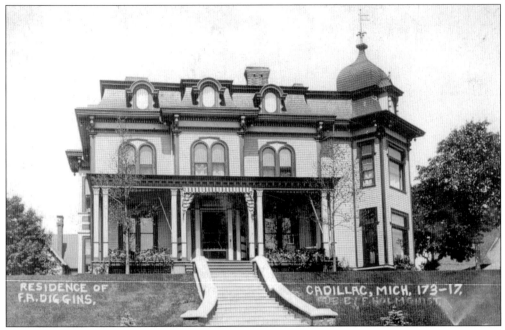

This extravagant Second Empire-style residence was built in 1874 by George A. Mitchell, founder of Cadillac. Overlooking Shelby and Beech Streets from its lofty incline, this home possessed the ideal vantage point for viewing both downtown and Lake Cadillac.

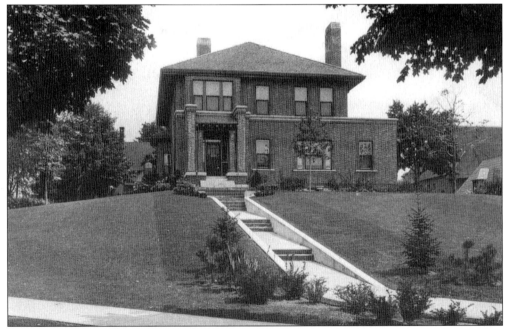

The George A. Mitchell home was later purchased and remodeled by Charles T. Mitchell, grandnephew of George, to resemble the popular Prairie Style architecture of the day. This postcard showing the recently renovated home was postmarked 1915, conflicting with information stating that the remodeling took place in 1926.

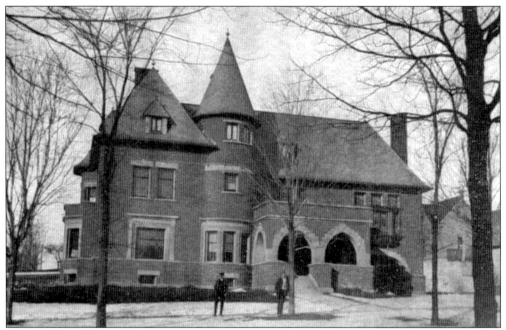

The residence of lumberman Delos Diggins was the most monumental home built in Cadillac in the early twentieth century. A popular subject for postcards, the Diggins residence was built in 1904 on Shelby and Harris Streets. The Chateau styling of the home is reflected in many of its exterior elements, including the high hipped roof with dormers and the steep turret.

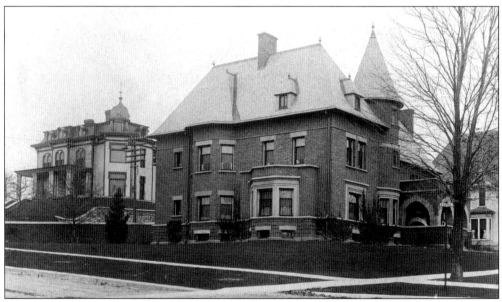

Dorothy Sorenson, a longtime resident of Cadillac, visited the Diggins home frequently when it was owned by the Clarence Williams family. She recalls the stunning interior details, gorgeous woodwork and elevator, which operated between the basement level and third-floor ballroom. Sadly, this home was sold to the phone company in 1941 and was razed in 1947 – less than fifty years after it was built.

Lost forever, these are the homes and shaded green lawns that once lined Cass Street, west of Shelby. All were sacrificed to create parking spaces and a drive-thru teller window behind the First National Bank, which stood on Mitchell and Cass.

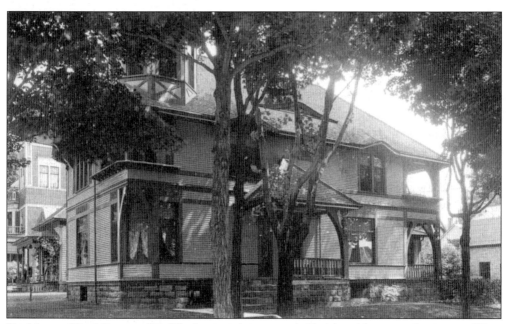

Dr. Mearue Wardell, one of Cadillac's revered surgeons, built this residence on the corner of Cass and Simons Street in 1874. Used as private offices today, the home has been exceptionally well-maintained and appears virtually unchanged.

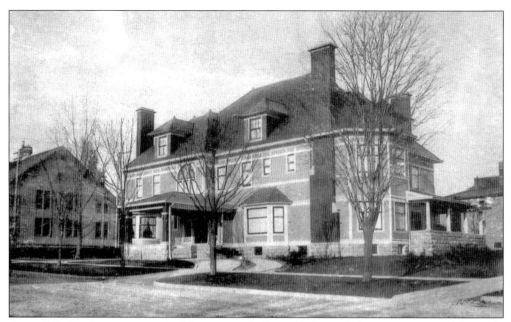

One of Cadillac's most recognized homes was built on Shelby and Cass Streets in 1890 by well-respected lumberman William W. Mitchell. This photograph shows the home's exterior after it was remodeled in the early 1900s and the porte-cochere was added. The small house shown east of the Mitchell residence was moved to Chapin Street.

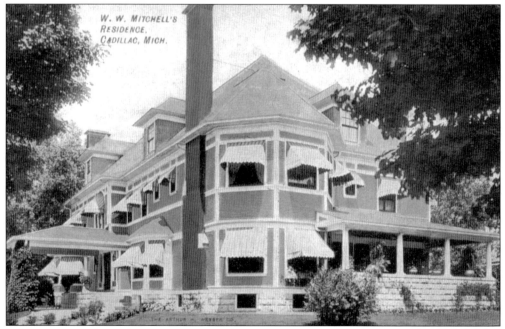

A front view of the William W. Mitchell residence shows the home fully dressed with awnings. After the death of Mrs. Mitchell in 1946, the home was purchased by J. Elmer Peterson for use as a funeral home. It remains Peterson's Funeral Home today. The porte-cochere has since been replaced by an enclosed main entrance room.

Tree-lined Cass Street was, "one of the principal residence streets of the city," according to the 1900 City Directory. This view, looking east from Shelby Street in the mid-1910s, follows the unpaved street to the top of the hill where it joins East Division.

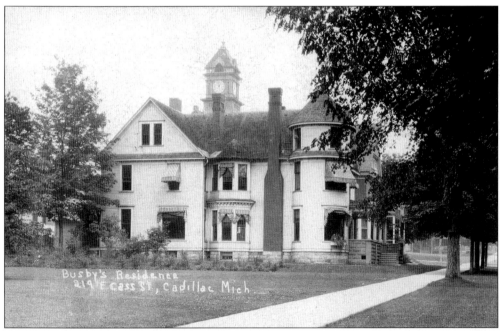

John and Sophia Busby, who commissioned this portrait of their residence at 213 East Cass Street, purchased the home in 1910. It still stands today, although it has experienced a succession of owners since 1883. The expansive yard, pictured west of the Busby residence, belonged to the William W. Mitchell home and later became the parking lot for Peterson's Funeral Home.

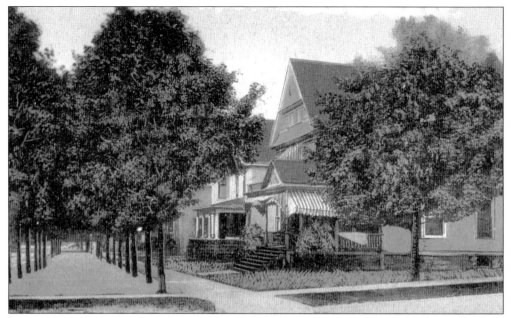

The residence of Dr. Bartlett McMullen is visible in this view of Cass Street, looking west from Simons Street. Dr. McMullen purchased the property in 1891, and later built this grand three-level home. A small turret is obstructed by the tree on Simons. Upon entering, guests were welcomed into a large receiving parlor with a fireplace and grand staircase.

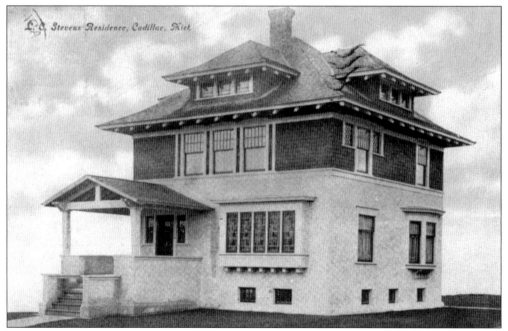

Leslie Stevens and his wife resided at, and perhaps even built, this home on the corner of Simons and Howard Street. Constructed sometime between 1900 and 1904, the exterior details of this home suggest Arts and Crafts styling and remain in wonderful condition today.

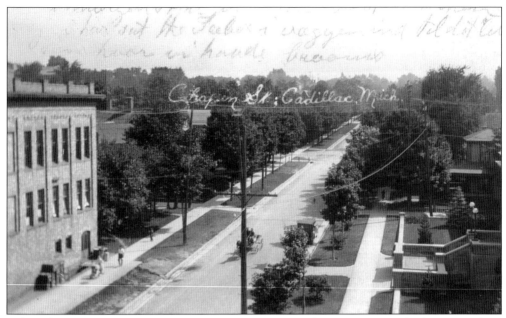

Taken from the Y.M.C.A. building, this photograph of Chapin Street, looking east from Mitchell Street, depicts the old Realty Building on the left, and the Cobbs & Mitchell Lumber Company offices on the right. Prior to the commercial development of this area in the mid-1960s, residences occupied the 100 block of East Chapin Street.

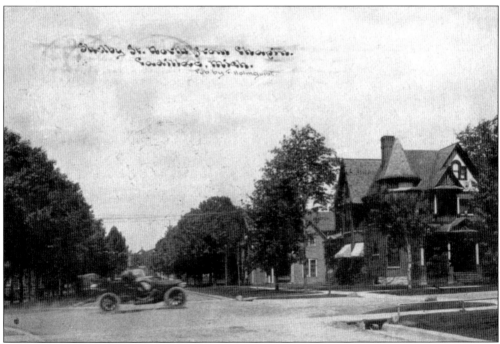

An early automobile makes its way up East Chapin Street, crossing the intersection of Shelby. The Victorian home on the corner was once the residence of Eugene F. Sawyer, one of the leading lawyers in northern Michigan according to the 1900 Cadillac City Directory.

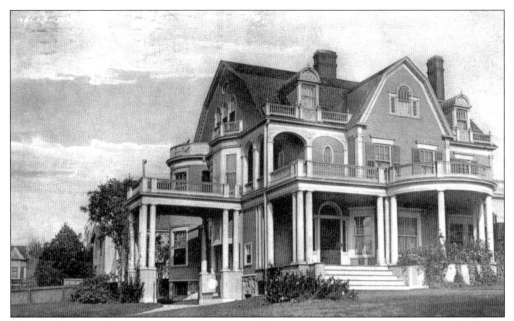

The Frank J. Cobbs residence, an architecturally commissioned home on Park and Chapin Streets, was built in 1898. It is believed that George Mason, architect of the Grand Hotel on Mackinac Island, designed this Dutch Colonial Classic Revival-style home. Lavish use of various hardwoods, finishes, tapestry, and Grueby tiles on two of the six fireplaces blend harmoniously throughout the interior.

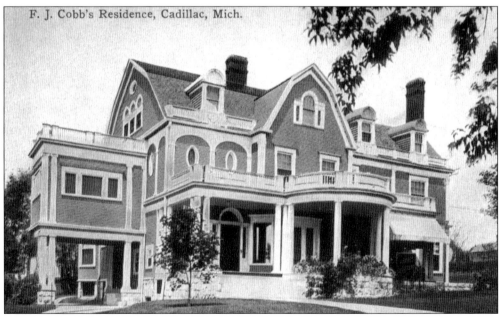

Additions to the Cobbs residence, made in 1905, can be seen in this photograph. They included a reading room with fireplace over the porte-cochere, enclosure of the second-story balcony, and expansion of the living area on the east side of the home. Extensive renovations have been made in order to re-capture the home's original splendor.

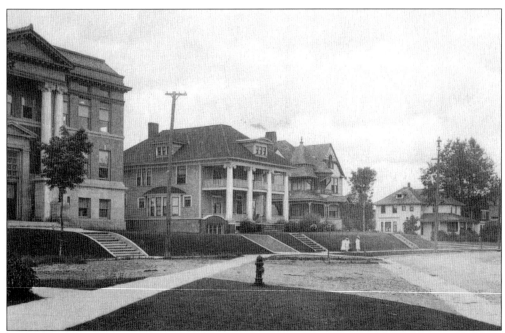

Today, the intersection of East Division and Harris Streets still resembles this early 1920s view. Standing next to the courthouse is the Torbeson residence, followed by the Austin W. Mitchell home, built in 1886. Many exterior details of the Mitchell home were altered over the years, including the removal of the rounded balcony and the front porch.

This stately residence, next door to the Court House, was occupied by the Clarence Williams family in the early 1900s. It is unknown if the home was built by Williams, but it preceded the construction of the Court House in 1912. With four large Ionic columns and dual porches, the home resembles a southern mansion. It was sold to Peter Torbeson in 1919.

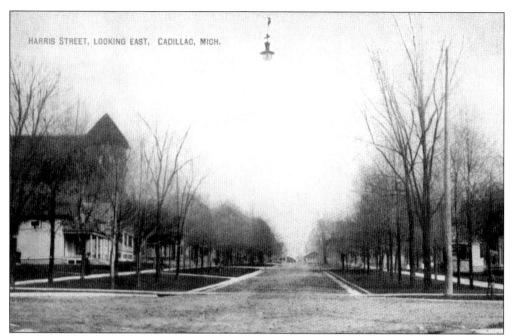

An early 1900s view of East Harris, looking east from the corner of Shelby, follows the gradual incline to East Division Street. This quiet residential street was also the location of three churches for many years: the Presbyterian, the Congregational, and the Methodist Episcopal. The bell tower of the Presbyterian Church is visible on the left side of the street.

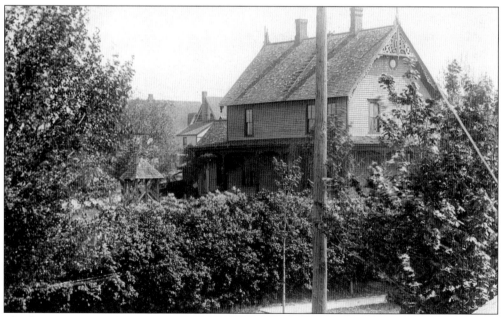

This home once stood at the present site of the Wexford County Courthouse and belonged to Dr. John Leeson, Cadillac's first physician and inventor of the world-famous Tiger Oil. Records indicate that the home was moved somewhere in the vicinity of Holbrook and South Garfield Streets. This photograph shows the home after it was relocated.

The use of postcards to exhibit pride in one's home was not limited to the wealthy. This house at 632 North Lake Street belonged to the John Christenson family in 1905. Written in Swedish, this postcard was mailed to Gust Christenson at the Mitchell Camp No. 22 in Jennings. Photographic processes allowed single postcards to be produced inexpensively.

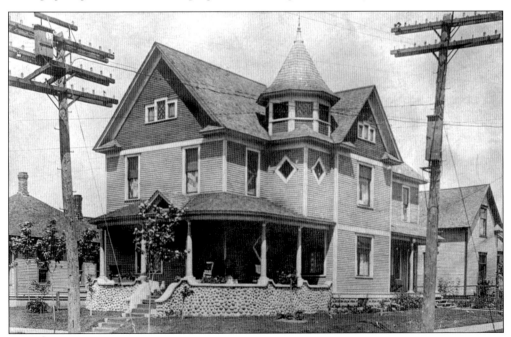

This residence still overlooks the intersection of Farrar and Wright Streets today. Although the corner turret has since been removed, the diamond-shaped windows and the front porch foundation (built using large rocks) remain some of the home's most distinguishing features.

Eight
EARLY CHURCHES

Churches have played an active role in the lives of Cadillac citizens since the town's earliest years. Before churches were constructed, members of congregations would meet in private homes or other buildings in town. In 1900, a total of 12 congregations appeared under the listing "Churches" in the Cadillac City Directory; 10 were featured in a special section highlighting the history of each congregation, along with photographs of the church and biographical sketches of the correlating clergyman. Although some of the featured congregations have changed their names, all are conducting services in Cadillac over 100 years later.

It is interesting to note that by the time postcards became popular in the early 1900s, many of Cadillac's congregations had already replaced older frame church buildings with masonry construction. This was true of the Presbyterian Church, which lost a frame structure to fire in 1903, and built the magnificent church which stands today. Before constructing new buildings, some congregations sold their original frame buildings to other congregations, and they were lifted from their foundations and moved to new locations. In later years, the need for larger facilities and parking lured some churches to more spacious locations away from town.

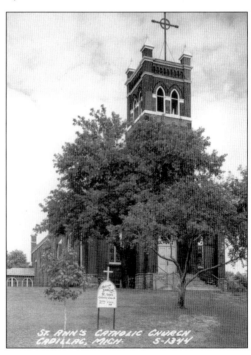

The former St. Ann's Church was set back on this sloping terrace facing Lynn Street. Construction of the church began in the summer of 1901 and was completed at a total cost of $15,000; this amount included all of the interior furnishings and decor. The ornate bell tower once supported a tall wooden steeple that was destroyed by fire and never replaced. In July 1982, construction of the new St. Ann's Church was underway on 13th Street, and the old St. Ann's Church was demolished to create additional parking for Mercy Hospital.

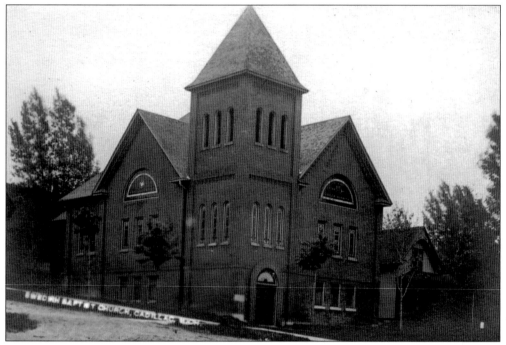

Built in 1907 at a cost of $7,000, the Swedish Baptist Church, on the corner of Shelby and Nelson Streets, replaced a smaller frame structure which dated from 1888. Later renamed Temple Hill Baptist Church, the building was used until 1973, when the congregation built a new church on West Division. It sat vacant until the mid-1990s and was finally razed.

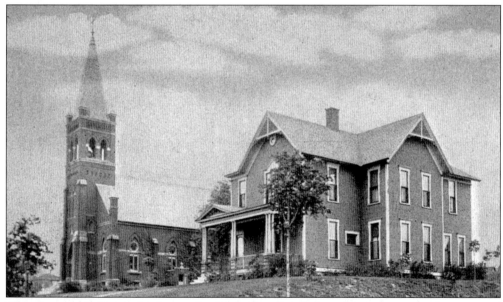

This photograph depicts the former St. Ann's Church and the original rectory on the corner of Lynn and Hobart Streets. The church was built as a replacement for the older frame church which stood next door, and was dedicated in 1903. A new rectory was built in 1925, and the former rectory became a convent for many years.

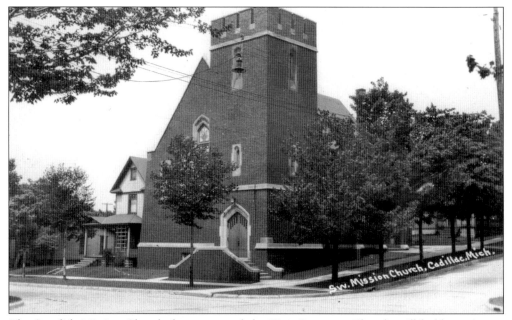

The Swedish Mission Church, later renamed the First Covenant Church, still holds services at this location on the northwest corner of Park and Pine Streets. This building was constructed in 1913 to replace the original frame church built in 1883. The house next to the church was later demolished to make room for the annex, which was added in the early 1960s.

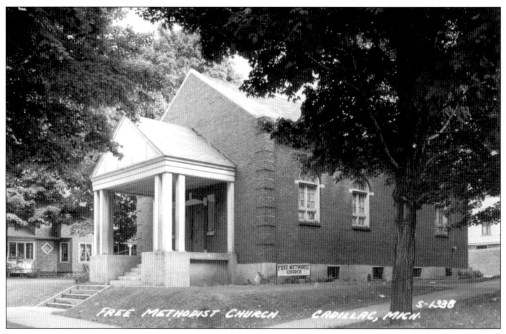

The southeast corner of Pine and Simons Street has been home to the Free Methodist Church since 1875. This quaint brick building, still in use today, replaced the original frame church which stood on this site.

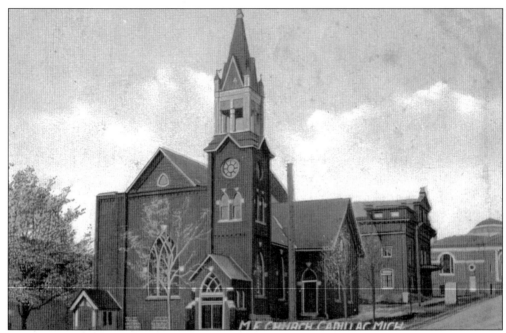

This view of the Methodist Episcopal Church on Harris Street, shown in the 1910s, follows Shelby Street past the Opera House to the Carnegie Library. Built in 1889, the church was remodeled extensively in 1928 and the tall steeple was removed. It was razed in 1973 after construction of a new church, and the site became a parking lot.

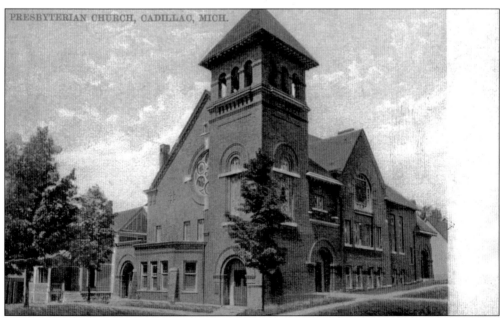

The current Presbyterian Church was built between 1904 and 1906 on Simons and Harris Streets to replace the frame church that burned in 1903. The stained-glass windows and bell tower are but a few of the building's many impressive features. The house shown next door, now gone, was the former manse of the church.

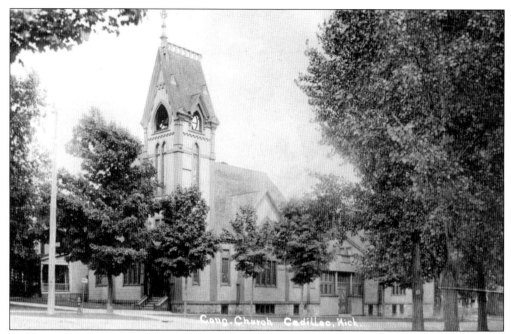

The original Congregational Church building stood where the present First Congregational United Church of Christ stands on the southeast corner of Harris and Shelby. Built in 1883, the church had the most unique and ornately trimmed steeple in town. After a fire, this church was replaced by the Colonial-style brick building which was dedicated in 1924.

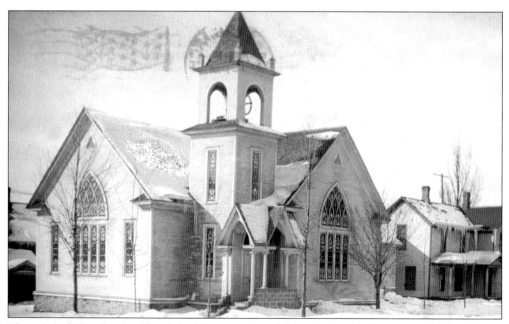

The original First Baptist Church building, purchased from the Methodist Episcopal Church, was moved to the corner of Shelby and Stimson Streets in 1888. This photograph shows the church after it was extensively remodeled in 1906. A new bell tower and steeple, large stained-glass windows, and a new front entrance were added. The parsonage is shown behind the church.

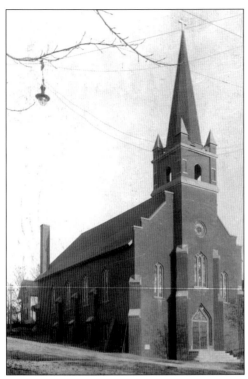

The Swedish Evangelical Lutheran Church, later renamed the Zion Lutheran Church, was built in 1909 on the incline of Nelson and Simons Street. This building replaced the frame church which had been sold to the Church of Christ in 1909 and moved one block down Nelson Street. This photograph shows the church before clocks were added to the steeple.

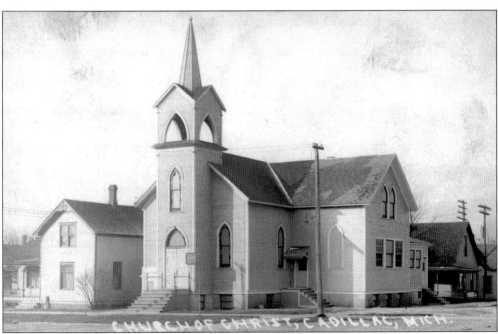

This building was purchased by the Church of Christ from the Swedish Evangelical Lutheran Church in 1909 and moved down the hill to the corner of Shelby and Nelson Streets, where it has remained ever since. Built in 1877, the church was restored by its current owner and is now a pottery studio and art gallery.

Nine
SCHOOLS OF THE PAST

In 1872, when Cadillac was still known as the Village of Clam Lake, village founder George A. Mitchell gave a portion of land to the young community for the sole purpose of constructing a centralized school building. On the north end of the block where Kirtland Terrace now stands, the first school was erected. It was described as a crude "shotgun" structure made of wood and consisted of three rooms. In 1876, this small building, the first in a succession of three school buildings, became inadequate to accommodate the growing school population.

By 1900, there were a total of five school buildings in Cadillac: a centrally located high school and four smaller "ward schools" that were situated in each of the four wards throughout town. This chapter begins with postcard images of the four ward schools in Cadillac as they appeared after 1900, and is followed by images of additional grammar schools that were constructed through 1909, including the original St. Ann's School. The central high school building, the most common school depicted on vintage postcards of Cadillac, is shown before, during, and after the school's dual-wing expansion in 1912. Of all the schools pictured on the following pages, none remain; many were replaced in later years by more modern facilities bearing the same name, such as Cass, Cooley, Franklin, McKinley, and St. Ann's elementary schools. A new high school was opened on Linden Street in 1952 and the old high school, used as a junior high until 1965, was later razed to make way for the construction of Kirtland Terrace.

Early Cadillac schools that deserve mention but have not been included for lack of images are the original Lincoln Elementary School, built in 1924, and the "second generation" brick versions of the Cass and Cooley school buildings, constructed in 1917 and 1923, respectively.

The 1920 Cadillac High School basketball team donned formal sweaters for this portrait. Holding the ball in the front row is George Pappin. The player seated to his immediate right is James Gibson, who in later years became instrumental in securing land for the Wexford County Airport.

The First Ward School, located on the corner of Linden and Haynes Streets, was built in 1882. Later renamed Cass School in 1906, this view shows the original frame schoolhouse, including a recent addition. This structure was replaced by a larger two-level brick building in 1917 at a cost of $30,000. The "second generation" brick Cass School was razed in the late 1970s.

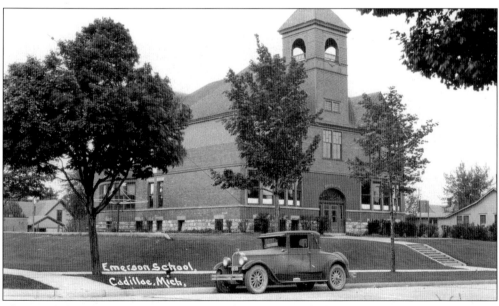

This view of Emerson School and a corner playlot, captured in the 1920s, shows the building in the context of the surrounding residential area on Stimson. Closed in 1934 as a cost-cutting measure, the school building served a brief stint as a mattress factory until it burned to the ground one month later. Today, the site is occupied by homes.

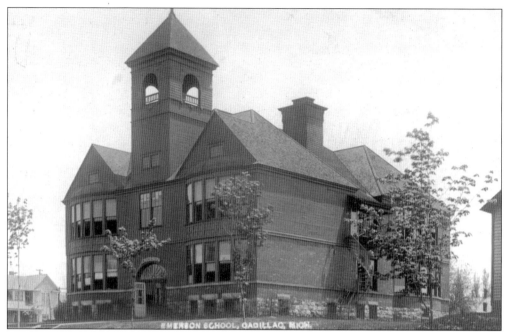

Emerson School, previously the Third Ward School, stood at the southwest corner of Stimson and Oak Streets. The original one-level, two-room structure was built in 1888. One year later, the school was expanded and two more rooms were added. In 1894, the entire structure was jacked up from its foundation and four more rooms were built underneath.

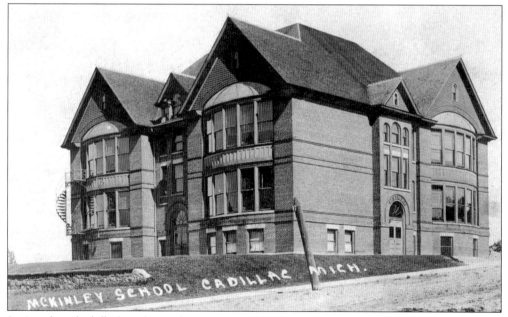

Stationed on the hillside at the northeast corner of North and Park Streets was the handsome Second Ward School, later renamed McKinley School. This 10-room building was constructed in 1899 to replace the original, which burned in 1898. In the mid-1950s, a new one-level McKinley School was built further east on North Street, and old McKinley was demolished in 1957.

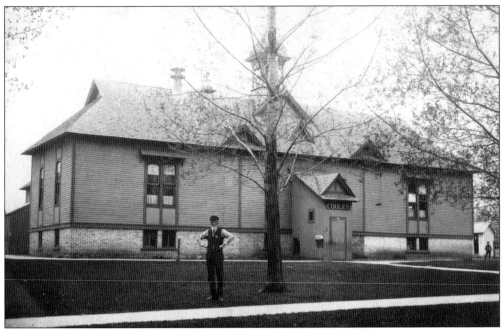

This photo of Cooley School from 1915 depicts the school janitor, Mr. McCloud, standing in front of the original frame building on Granite Street. Constructed in 1885 as the Fourth Ward School, the schoolhouse was built at a cost of $1,353 on two lots that were donated by the Cobbs & Mitchell Lumber Company. This school was later replaced by a brick building.

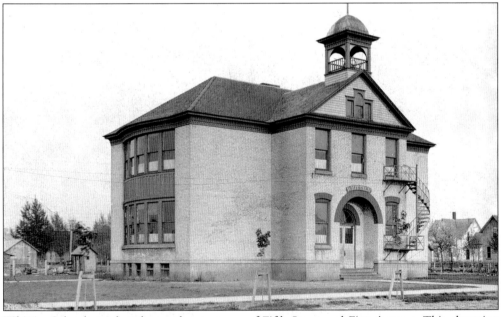

Whittier School stood at the northeast corner of Fifth Street and First Avenue. This charming brick school, which only taught up to the fourth grade, was built in 1905. It became the County Normal School in the 1930s, a facility used to train school teachers. Whittier reverted back to use as an elementary school until the late-1950s. It was later sold and razed.

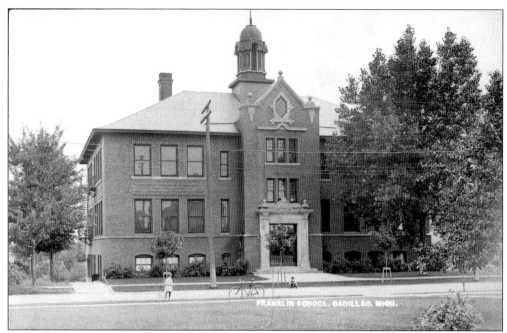

Cadillac's need for additional and more modern grammar school facilities after 1900 prompted the construction of the Franklin School on East Division and Delmar Streets in 1909. This school was replaced by a newer, one-level Franklin School between Carmel and Lester Streets in the late 1950s.

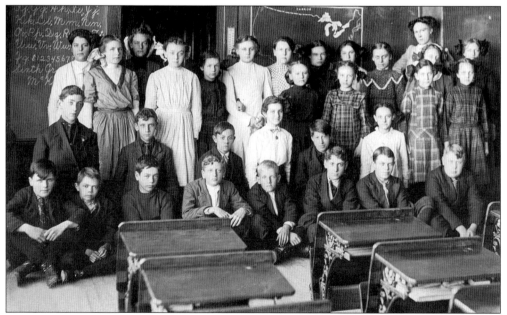

This is a picture of Rosalie Erikson's sixth grade class, taken inside the new Franklin School on March 27, 1911. Rosalie is the third pupil from the left in the back row. She later graduated from Cadillac High School in 1917.

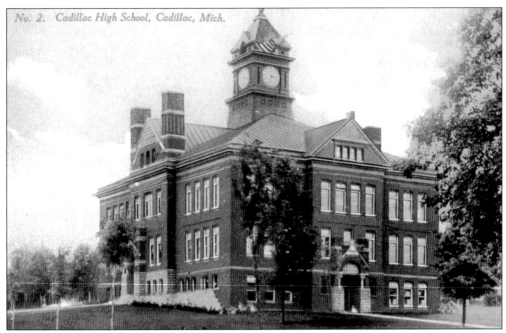

The first school building in Cadillac with masonry construction was the old high school, bounded by Harris, Cass, Simons and Park Streets. After two frame schools were lost to fires in less than 10 years, brick and mortar became the building material of choice — and necessity. Construction began in fall 1890, and the school opened in 1891.

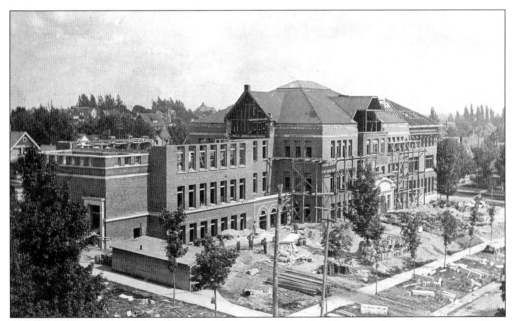

A gift of over $120,000 from Esther Diggins, widow of wealthy lumberman Delos Diggins, provided funding for the addition of two three-level wings to the high school building in 1912. This photo, taken from the Presbyterian Church on Harris and Simons Streets, shows the progress of the construction. Note that the clock tower from the original building was removed.

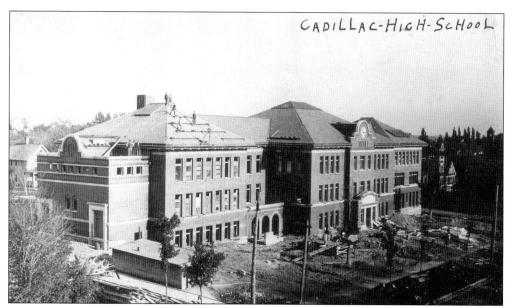

Construction of the high school addition continues as workmen complete the roof on the north wing of the building. New clocks were installed over the front and rear entrances of the building on Simons and Park Streets.

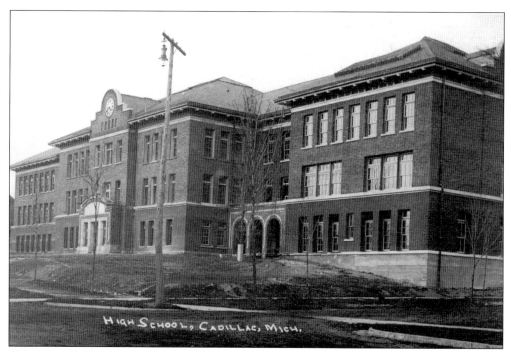

The remodeled high school is near completion. Everything appears to be in place except for landscaping and interior finishing work. The message written on the back of this postcard dated February 1, 1912, indicates that some areas inside the building were still not accessible to students.

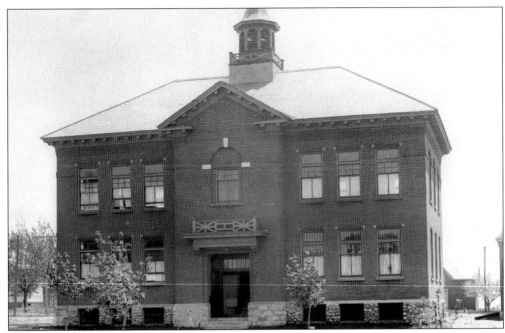

The first St. Ann's School was constructed in 1908 at a cost of approximately $8,000. The handsome two-level brick building opened in 1910, on the corner of Evart and Oak Streets, and was on the same block as St. Ann's Church. First through eighth grades were taught at St. Ann's, where two grades shared one classroom.

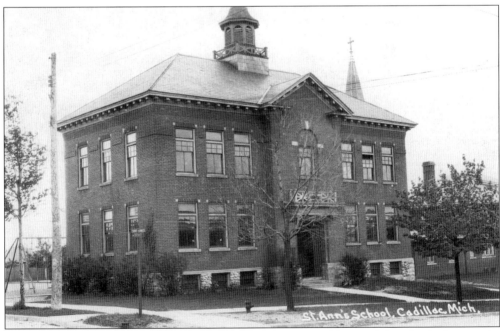

The swingset and playground are visible in this photograph of St. Ann's School. Due to the steady increase in enrollment, the school became crowded and was replaced by a larger facility in 1958. The original school building was razed in 1969 to create additional parking for the church.

Index

A.H. Webber Co. 47	Chapin Street 53, 55, 56,	Fifth Street 122
A & P Foods 46	84, 108, 109	Firkins, Judy 67
Acme Motor Truck Company	Christenson, John 112	First Avenue 76, 122
35, 84, 85, 94	Church of Christ 118	First Baptist Church 117
ALNU Vaudeville Theatre 45	Churches 87, 101, 111, 113-18	First Congregational United
American House 36, 88	City Hall 34, 35	Church of Christ 117
(see also Russell House)	City Park 62-64, 90	First Covenant Church 115
American Legion Post No. 94 28	Clam River 81, 84	First National Bank 104
Ann Arbor Railroad 62, 63, 65, 67	Clarks Studio 94, 95	First Ward School 120
B.F. Goodrich Company 85	Clover Farm Stores 28	Fourth Ward School 122
Beacon Bar 70	Cobbs, Frank J. 109	Franklin School 123
Beatrice Creamery Co. 82	Cobbs & Mitchell Lumber Company	Free Methodist Church 115
Beech Street 32, 36, 37, 60, 102	56, 74, 108, 122	G. R. & I. Railroad 64, 80
Big Clam Lake 17	Cooley School 122	Gallivan's Beauty & Barber Shop 31
See also Lake Mitchell	Co-Operative Hotel 29	Garneau, Joe 99
Big Cove 24	Congregational Church 101, 117	Gibson, James 119
Blodgett Street 90	Copier, Guy 33	Gotha Aid Society 28
Boulevard Drive 12-16, 92	Cornell's Lakeside Resort 12	Gotha Temple 28
Bremer Street 28	County Normal School 122	Granite Block 27, 43, 94
Bricault, Ray 37	Cummer, Jacob 29	Granite Street 122
Brown, Ted J. 38	Cummer & Diggins 32	Gunn Street 79
Busby, John and Sophia 106	Cummer Lumber Company 32,33	H. Chris Jorgensen, Clothier 38
Busby's Restaurant 67	Cummer Manufacturing Company 75	H. L. Green & Co. 27, 43
C. A. Olson Shoes 39	Cunningham's Drug Store 43	Haring Street 80, 91
Cable Piano Company 11	Dad and Ma's Barbecue 70	Harris Street 2, 27, 36, 40-42, 43, 47,
Cadillac Boat Club 10, 11	Delmar Street 123	49, 58, 65, 66, 82, 88, 95, 99, 101,
Cadillac City Roller Mills 50	Diggins, Delos 68, 103	110, 111, 116, 117, 124
Cadillac Evening News 32	Diggins, Esther 124	Haynes Brothers Lumber Company
Cadillac Fire Department 34, 35	Drury Block 95	84, 97
Cadillac Gun Club 15	Drury Hardware 31	Haynes Street 12, 81, 84, 85, 120
Cadillac High School 119	East Division Street 61, 90, 110,	Hedequist, Enoch 38
Cadillac Lumber Company 77	111, 123	Hemlock Park camp 24
Cadillac Machine Company 82	East Lake Mitchell Drive 22	Holmen Brothers 16, 98
Cadillac Opera House 59, 116	Economy Bazaar 33	Holmquist, Frank 51
Cadillac Printing Company 45	Elk's Temple 49	Hobart Street 114
Cadillac Produce Company 82	Emerson School 120, 121	Hotel Cadillac 51, 54
Cadillac Square Shopping Center 74	See also Third Ward School	Howard Street 107
Cadillac State Bank 27, 45, 48, 66	English News Agency 36	Idlewild 10, 15, 18, 19, 24
Camp Torenta 21	Erikson, Rosalie 123	Indian Trail Inn 23
Canal 14-17, 24, 92	Ernst Building 28	Irwin's Pine Rest 22
Carmel Street 123	Ernst, Fred 28	J.C. Penny Company 47
Carnegie Library 60, 116	Evart Street 89, 126	James Johnston Grocers 54
Cass School 120	F.W. Woolworth Co. 27, 46	Johnny's Steak Burgers 70
Cass Street 27, 45, 46, 48, 49, 51-53,	Farmer Peet's Meat Products 28	Johnson's Hardware 53
55, 63, 67, 88, 89, 101, 104-07,	Farrar, Frank L. 82	Johnson, Herb 70
124	Farrar Street 112	Johnson, Jess 37

Jorgensen Block	38	
Jorgensen, H. Chris	2, 38, 90	
Kelly Block	2	
Kelly, George	48	
Kelly & Mather Livery Stable	58	
Kelly's Restaurant	27, 48	
Kenwood	10, 13, 14	
Knapp's Clothing	36	
Kraft Foods	82	
Kroger's	46	
Kryger Furniture	50, 54	
Kryger, Henry	50	
Kysor, Walter A.	82	
LaBar & Cornwell building	50, 51	
Lake Cadillac	9–15, 17, 18, 24–26, 62, 63, 74, 86	
Lake Mitchell	10, 17, 20–22, 25	
Lake Street	63, 82, 84–86, 112	
Lakeside Resort	13	
Leeson, Dr. John	29, 111	
Lester Street	123	
Linden Street	120	
Little Clam Lake	25	
See also Lake Cadillac		
Little Cove	25	
Little Tavern Restaurant	28	
Logging, *see* Lumber industry		
Logging Train	75	
Long Bridge	25	
Louis Grillo Fruits	54	
Lumber industry	13, 17, 24, 25, 71–86	
Lunch Room, the	51	
Lynn Street	113, 114	
Lyric Theater	45, 52, 53	
Malleable Iron Company	83	
Maple Hill Cemetery	57	
Mason Café	54	
Mason Street	2, 82, 93	
Masonic Temple	32, 33, 50	
McKinnon House Hotel	2, 36, 40, 41, 88, 96	
McKinley School	121	
McMullen, Dr. Bartlett	107	
Mercy Hospital	68, 69, 113	
Methodist Episcopal Church	116, 117	
Miller's Café	30, 31	
Miller, Dr. Devere	44	
Mitchell, Austin W.	110	
Mitchell Brothers	57, 75	
Mitchell & Diggins Iron Furnace	83	
Mitchell, George A.	102	
Mitchell, William W.	101, 105, 106	
Mitchell State Park	10, 14, 15, 18–20, 24	
Mitchell Street	2, 27–56, 70, 80, 88, 91, 94, 95, 97, 108	
Moutsatson's Sodas	45	
Murphy & Diggins	86	
Nelson Street	29, 114, 118	
North Mitchell Street	2, 28–30, 36, 39, 80, 91, 95	
North Street	28, 121	
Northern Chair Company	76	
Northwood Barber Shop	40	
Northwood Coffee Shop	36	
Northwood Hotel	40, 41	
Oak Street	68, 121, 126	
Odd Fellows	29, 55	
Oleson's Shopping Center	55	
Palace Theater	51	
Park of the Lakes	16, 92, 98	
Park Street	109, 115, 121, 124, 125	
Peace Parade	4, 94, 95	
Pennsylvania Railroad	42, 64, 66, 67, 93	
Peoples Savings Bank	38, 39, 48, 97	
People's Drugs	28	
Peterson's Funeral Home	105, 106	
Pine Street	10, 29, 31, 82, 86, 115	
Platters, The	16	
Popcorn John	38, 97	
Post Office	58	
Presbyterian Church	111, 116, 124	
Present's Dry Goods	36	
Railroads	62–66, 75, 80, 93	
Realty Building	55, 108	
Red Cross	94	
Reed & Wheaton's Jewelers	44, 46	
Residences	21, 89, 90, 101–12	
River Street	91	
Rocks, The	26	
Roundhouse Lumber Company	80	
Royal Hotel	66, 99	
Rupers Meat Market	54	
Russell House	39, 88, 95	
See also American House		
Sahlmark Drugs	30	
Sandy's Jewelry	36	
Sawyer, Eugene F.	108	
Schools	119–26	
Second Ward School	121	
Seventh Street	76	
Shelby Street	58, 60, 101, 102, 105, 106, 108, 111, 114, 116, 117	
Shopping Basket	36	
Simons Street	87, 89, 104, 107, 115, 116, 118, 124, 125	
Sisters of Mercy	68	
Smith Brothers	53	
Snow White Sandwich Shop	36, 37	
Sorenson, Dorothy	103	
South Mitchell Street	27, 42, 44, 45, 51–54, 70, 94	
South Shore Motel	26	
Spruce Street	31–33	
St. Ann's Church	113, 114	
St. Ann's School	126	
St. John's Table Company	76, 78, 95	
Steamers	9, 10, 14, 18, 25	
Stephan's Drugs	36	
Stevens, Leslie	107	
Stimson Street	117, 120, 121	
Sun N' Snow Resort	23	
Sunnyside Drive	26	
Sunset Shores	26	
Swedish Baptist Church	114	
Swedish Evangelical Lutheran Church	118	
Swedish Lutheran Church	87	
Swedish Mission Church	115	
Swift & Co.	82, 95	
Taylor's Grove	14	
Temple Hill Baptist Church	114	
Third Ward School	121	
See also Emerson School		
Thirteenth Street	80	
Tom Plett Clothing	31	
Torbeson Drugs	30, 31	
Torbeson, Peter	110	
US-131	70	
Vander Jagt, Harry	100	
Viking Dairy Bar	55	
Wardell, Dr. Mearue	44, 104	
Water Works	86	
Watson, Dick	38	
Webber Block	47, 88	
Webber Drugs	36	
Wesleyan Methodist Campgrounds	15	
Wexford Café	54	
Wexford County Courthouse	61, 110, 111	
Wexford County Historical Society Museum	60	
Wexford County Jail	61	
White City	20	
White's Hardware	31	
Whittier School	122	
William McAddie & Co.	82	
William W. Mitchell State Park	10, 14, 15, 18–20, 24	
Williams, Clarence	110	
Wolgast, Ad	96	
Wooley's Drug Store	47	
Wright Street	112	
Y.M.C.A. building	56, 108	
Y.M.C.A. camp	21	
Zion Lutheran Church	118	